IN & AROUND SANDSEND

THROUGH TIME

Alan Whitworth

AMBERLEY PUBLISHING

To Dougie and Irene Raine, once proud owners of Sandsend Stores who still play a significant role in the life of the village, and who gave me encouragement when researching and writing a history of Sandsend.

First published 2013

Amberley Publishing
The Hill, Stroud
Gloucestershire, GL5 4EP

www.amberley-books.com

Copyright © Alan Whitworth, 2013

The right of Alan Whitworth to be identified as the Author of this work has been asserted in accordance with the Copyrights, Designs and Patents Act 1988.

ISBN 978 1 84868 568 0

British Library Cataloguing in Publication Data.
A catalogue record for this book is available from the British Library.

Typeset in 9.5pt on 12pt Celeste.
Typesetting by Amberley Publishing.
Printed in the UK.

Introduction

Sandsend is a village of contrasts; of two halves. One rural, the other formerly industrial, though today the visitor and resident alike would be hard put to picture the village suffering under the pall of smoke, grime and stench. That it is a village of two halves, or more correctly two separate hamlets, came about through its situation on two distinct waterways, the northernmost from Whitby being named Sandebeck and the nearest Estbeck, which is the watercourse that is first crossed on the coast road from Whitby which is distant 3 miles. The high tongue of land which separates the two is called 'The Riggs'.

In the twenty-first century the picture of Sandsend is of a rural idyll, perhaps not so far removed from when Ptolemy wrote about *Dunnum Sinus* – the bay of Dunsley. At this period Sandsend was known as 'Thordisa', from a heathen temple erected here by Saxons to their god Thor. This site is believed to have been about 200 yards south of the bridge in a natural amphitheatre.

The Revd J. Graves in his *History of Cleveland* (1808) described 'Sands-end' as 'a hamlet within the township of Lythe, situated on the face of a rocky cliff near the sea'. This was never really an accurate assessment of its location, but in part it does cling to the sides of a steep valley. At its earliest period it was an insignificant inlet, no more than a landing place for lost fishermen and invaders, who arrived here and made their way inland to Dunsley and Mulgrave.

The name Dunsley is derived from the Celtic word *Dun*, a fortified hill, and *ley*, meaning land reclaimed from the forest or marsh, and there is every evidence that the hill on which the school is built was once surrounded by water on three sides. In order to show the antiquity of other place names around here it is only necessary to mention the word 'Raithwaite' – a Celtic word meaning 'a hill in water' – 'Newholm' the Saxon word for 'new dwelling' – and 'Thordisa' itself, which is Scandinavian for 'house'.

Sandsend was a good landing place for the Romans and later Danes who came as early as AD 876. A hill above the village is known as Raven Hill, so called from where the Vikings planted their standard – a raven – according to many historians. Other evidence of the district's Viking ancestry can be found in the many carved stones found at Lythe, and collected in the church of St Oswald.

At the time of the Norman 'Conquest' neither Sandsend nor Mulgrave existed. The great Domesday Book tells us that Lythe (called Lid), Hutton Mulgrave, and Egton, were all manors held by a Dane called Sveinn or Suuen; therefore it may be inferred that he held 'Griff' (or Grave) – as Mulgrave was so known – before being dispossessed and the manor given to the Count of Mortrain, who put in as under-tenant Nigel Fossard (died *c.* 1091), a companion of William I 'before the conquest, at the conquest, and after the conquest'. It was Nigel Fossard who erected Mulgrave Castle.

The earliest mention of a settlement at Sandsend was in 1200, when it was known by the name of Sandyford. In 1218 'a man from Sandeshande' was within the gift of Grosmont Priory. At this period it is said Sandsend possessed fifty-three tenants' cottages.

In time Sandsend rose from insignificance to a profitable fishing village, and then later, the discovery of alum in the district transformed Sandsend into a busy and noisy industrial centre, with an increase in housing and population. Growth brought problems, however, such as smuggling, dirt and disease.

Today, of course, Sandsend little resembles the village of two or three hundred years ago. The two villages are now united, and many of the old cottages have been removed. The cement works have gone, so too the alum works, the two great railway viaducts and the camping coaches, and much of the seafront had to be replaced following tremendous storm damage in 1953 which devastated the East Coast. But one thing remains constant: Sandsend possesses some of the finest beach in the North of England and in the nineteenth century; it brought the tourist and holidaymakers, who in turn helped to sustain the community, allowing it to become the tranquil haven that it is.

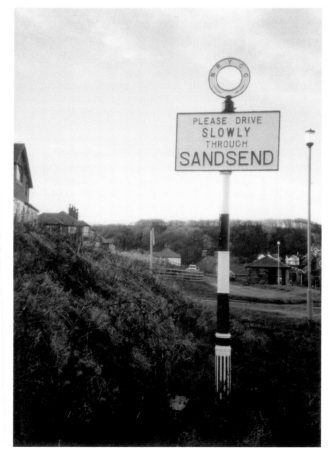

A sign of the times, c. 1960.

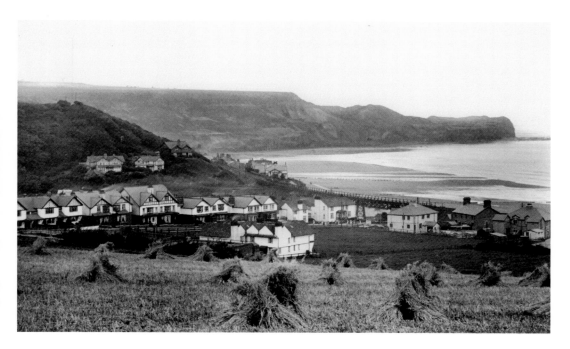

Sandsend, Meadow Fields and Kettleness Nab, 1925

Following the Norman Conquest the land was continually reclaimed from the forests and moors for agriculture purposes, a process that had begun under the Saxons and Danish settlers. At least half the parish of Sandsend, however, still remained to be got from the natural wilderness and the boundaries of the villages would have been poorly defined. People lived in hovels and fields would have been small and irregular in shape, not like the present system which came about after the Enclosure Acts. Today, the selfsame field above has been left to revert back to pasture.

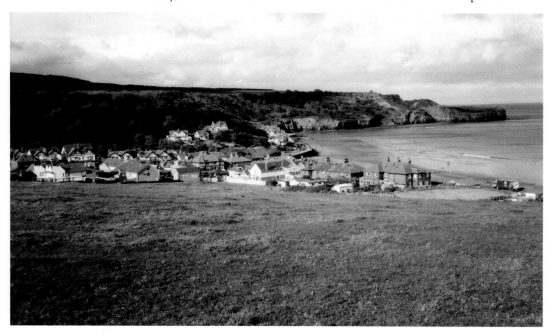

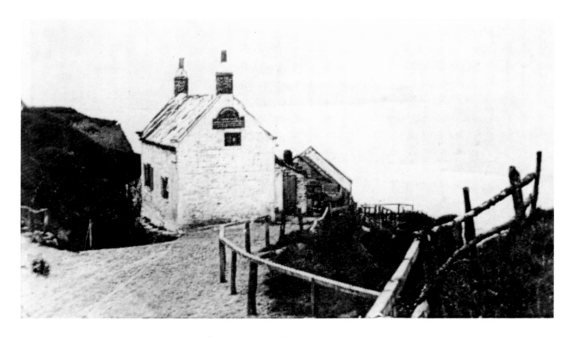

The Old Mulgrave Castle Inn and the Ship Launch Inn
A problem with living so close to the land's edge was the constant battle to arrest the erosion. The inn above marked where the residents of Whitby took to the beach on journeys to Sandsend. This eventually tumbled into the sea; however, by that date it had a fearsome reputation as a haunt of smugglers. Smuggling was carried on in these parts for centuries, and the inn below on Baxtergate, was another haunt of the smuggling fraternity. Today its name has been changed to the Old Smugglers Café to reflect its past history.

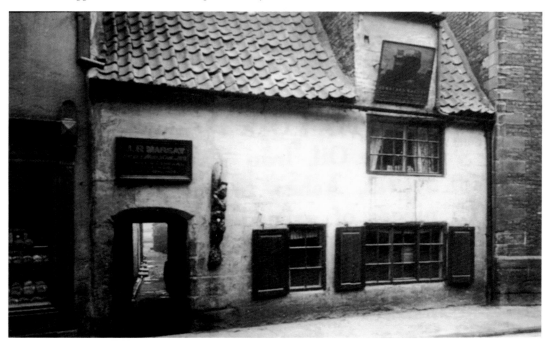

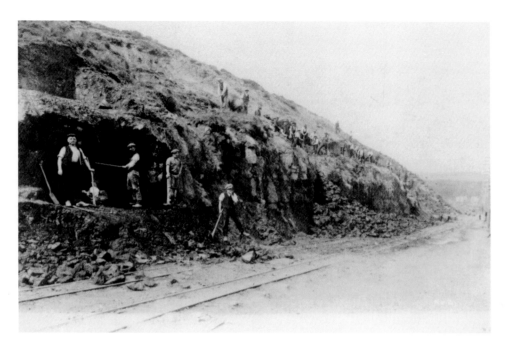

Building the Whitby–Sandsend Road
In the County Hall at Northallerton there is a plan dated 1794 showing the road from
Whitby to Sandsend in the form of a causeway on the sands along the foot of the cliffs.
This road was frequently submerged at High Tide and became so inconvenient that in 1860
the Maharajah Duleep Singh, who was then leasing Mulgrave Castle above Sandsend, built
a road partly at his own expense along the edge of the cliffs as a more convenient way into
the town. This series of photographs shows the rod under construction.

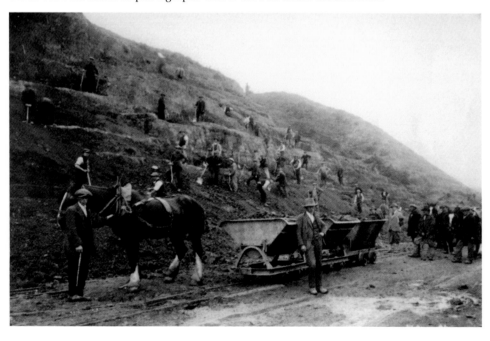

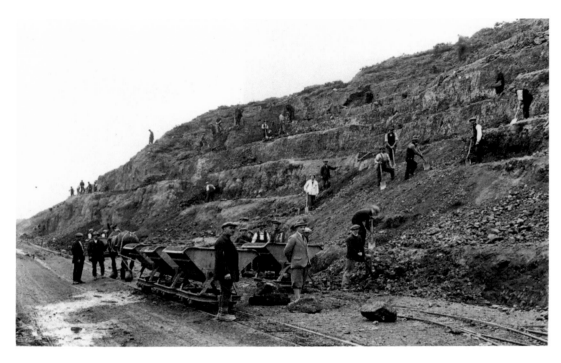

Building the Whitby–Sandsend Road II

Along with the construction of a new railway along the coast, the Maharajah's Road as it was first known, came to serve as the main communicating link between Whitby and Sandsend and the coastal towns and villages beyond. Essentially a private venture, it was maintained by the Marquis of Normanby and with the aid of tolls collected from the occasional travellers who ventured to use the highway and under the control of a committee, its expenditure was reclaimed.

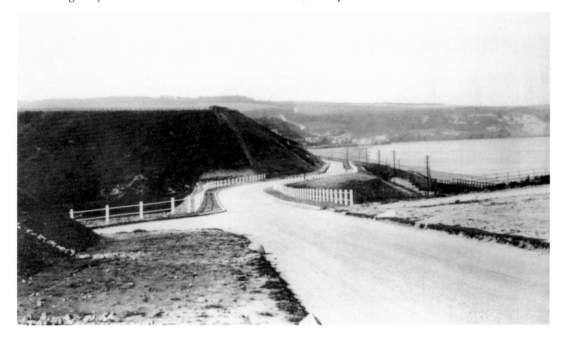

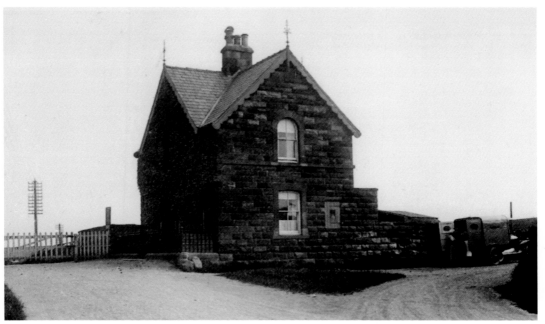

The Whitby–Sandsend Toll House
In 1907 the Rural District Council of Whitby presented a memorial to the North Yorkshire Council petitioning for the road to be dedicated to the public on account of the increasing traffic which, calculated by the receipts from tolls at that time, amounted to as much as forty to fifty vehicles per day. Mr Pyman, of Raithwaite Hall, who had acquired the rights to the road offered to remove the toll and give the necessary land for the improvement of the road and the Marquis of Normanby also generously offered any land for the improvement.

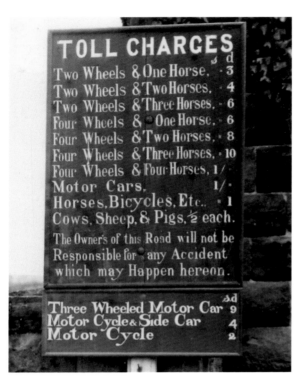

TOLL CHARGES

	s d
Two Wheels & One Horse.	3
Two Wheels & Two Horses.	4
Two Wheels & Three Horses.	6
Four Wheels & One Horse.	6
Four Wheels & Two Horses.	8
Four Wheels & Three Horses.	10
Four Wheels & Four Horses.	1/
Motor Cars.	1/
Horses, Bicycles, Etc.	1
Cows, Sheep, & Pigs, ½ each.	

The Owners of this Road will not be Responsible for any Accident which may Happen hereon.

	s d
Three Wheeled Motor Car	9
Motor Cycle & Side Car	4
Motor Cycle	2

Whitby–Sandsend Road Official Opening

The construction of the road took three years, being laid down in sections, and required two valleys to be filled in to make the necessary level. The excavations removed over 150,000 cubic yards of material, and the cost amounted to approximately £50,000. This was provided by the Ministry of Transport (£25,000), The North Yorkshire County Council (£12,500), The Whitby Urban District Council (£6,250) and the Whitby Rural District Council (£6,250). The highway was officially opened by the Minister of Transport, Lt-Col The Right Hon. Wilfrid Ashley MP on Saturday 7 November 1925.

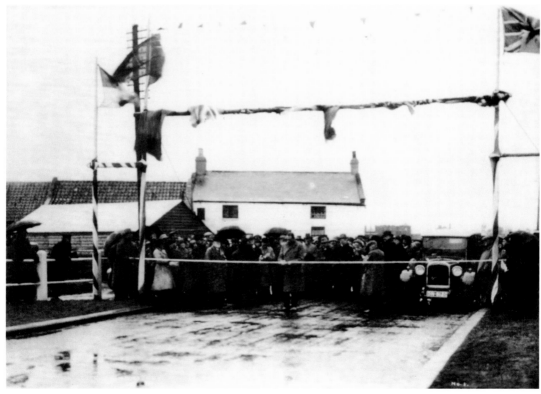

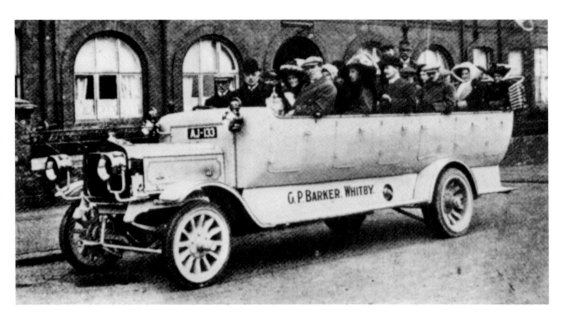

Sandsend Enters the Motoring Age

With the opening of the road link, Sandsend quickly became a favourite destination for holidaymakers taking day excursions. Soon charabanc trips where organised between Whitby town and Sandsend, and even as far as Lythe and beyond. Although the charabanc died away after the First World War with improvements in transport design, in modern times there has been a resurgence in all things nostalgic. Vernon and his 1929 'Dennis' charabanc sometimes runs trips down to Sandsend on summer nights, while throughout the summer his steam bus 'Elizabeth' as well as 'Dennis' run daily guided tours around the town.

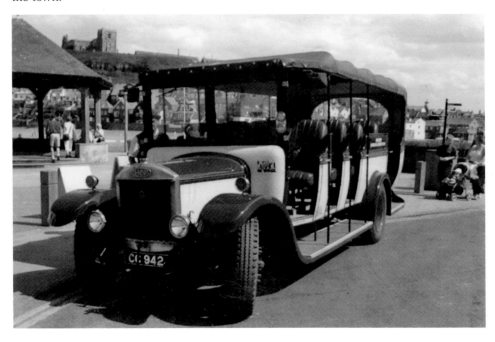

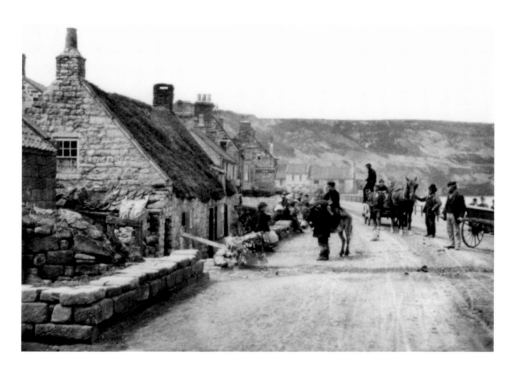

The Promenade, *c.* 1870

The heyday of smuggling was from about 1750 until 1830, and it is alleged that at times during that period some areas were virtually besieged by organised smuggling gangs. Sandsend was well placed to play a role in the smuggling trade. As early as January 1723 William Selby, the Customs Surveyor at Whitby, found four ankers of brandy and two bags of tea packed on a horse, which was being led along the shore from Sandsend by a man called Patton. Both goods and horse were duly seized and auctioned, raising a staggering sum of £73 10s 0d.

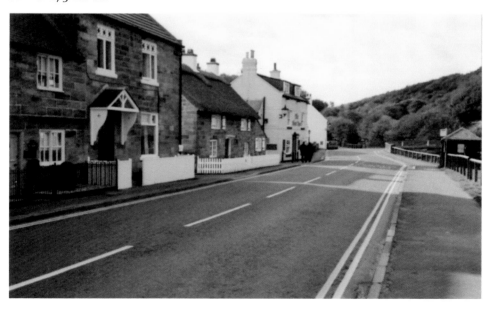

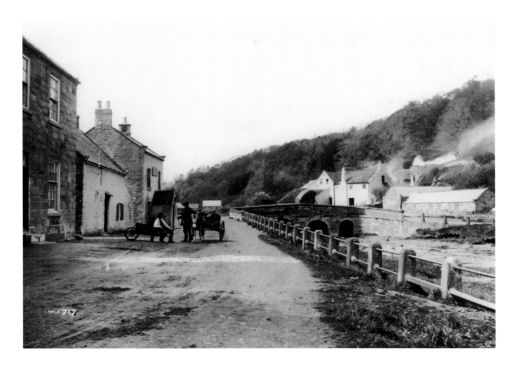

More Tales of Smuggling

In January 1756, the village featured in the annals of smuggling when an Excise Officer stopped three men on the road out of Sandsend who were moving some contraband goods. The men decided to make a stand and started to attack with knotted whips and an iron bar. Despite being badly bruised and shaken, the Excise Officer managed to fire off both his pistols which, although the shots missed his assailants, frightened them sufficiently to take to their heels and disappear into the woods. A local innkeeper was persuaded into storing the geneva (gin), tea, and chocolate overnight.

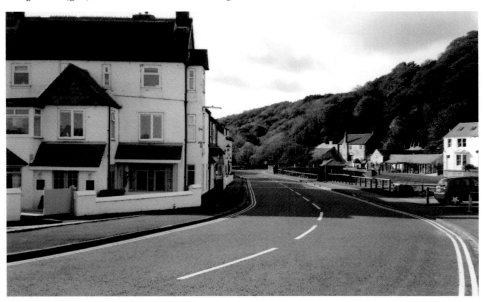

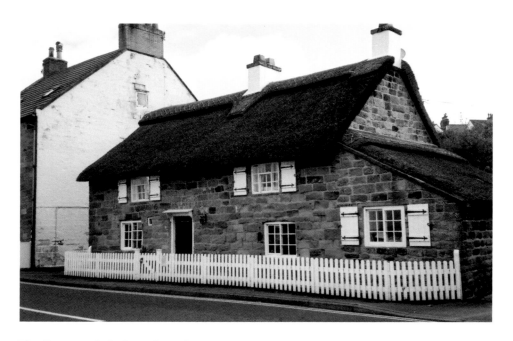

The Promenade in Days Gone By

The buildings at this point are a mixed collection dating from the sixteenth century up to the early years of the nineteenth. Their occupants also varied in wealth and position. A Mr Ralph Ward, who kept a journal concerned with his affairs, noted on the '5 February 1755 Mr Milburn, of Lyth, called at Boulby to treat [bargain] about my warehouse at Sandsend. I set him £150 for the purchase', which he must have declined for on '1 November 1756. Thomas Knaggs, the Tanner, came to speak to me about my Stable at Sandsend for the new officer of Excise at [that] place'.

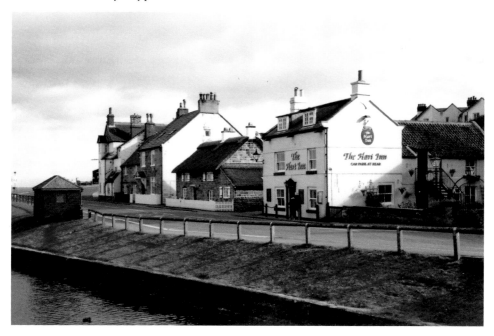

Changing Times

My acquaintanceship with Sandsend began in the early 1950s when, as a family, we would regularly holiday here. Twenty-five years ago I came to live in Whitby. During my time away little had changed; the greatest changes were wrought by nature eroding the coast. The railway fell into the waves, so too did the Second World War defences in the shape of pillboxes which I played in as a child on the beach. Sadly, today the greatest changes appear to be made by builders in their quest for profits with new housing developments.

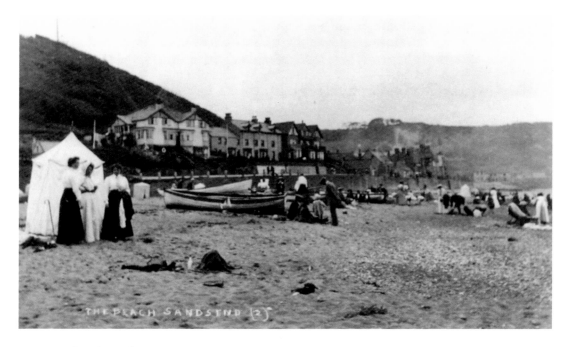

Sandsend Beach, *c.* 1920

Although the local photographer called this view 'The Beach Sandsend', it is actually the hamlet of East Row and Sandsend is in the distance. This stretch of sand has always been popular and many of the people would have been staying at one of the lodging houses along this seafront. Sandsend Beach is one of the few stretches of sand that still retains its groynes (below), low wood walls set at right angles to prevent the sea washing all the sand away, and contributes to its fine quality.

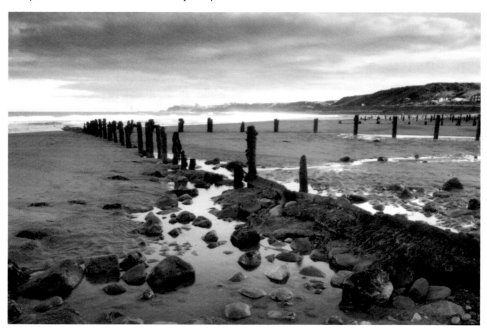

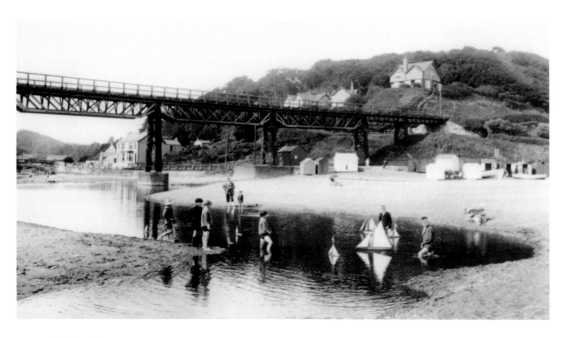

The Beach, c. 1925

The coastal railway ran behind the seafront boarding houses and had to cross both the rivulets of East Beck and Sandsend Beck. This was achieved by the construction of massive iron viaducts. Lewis Carroll was a frequent visitor to the district and was familiar with the Golden Sands poem which inspired him to mention their quality in the poem, 'The Walrus & Carpenter'. He could often be found on the beach telling stories to groups of children and was always remembered so by the local Whitby photographer Frank Meadow Sutcliffe.

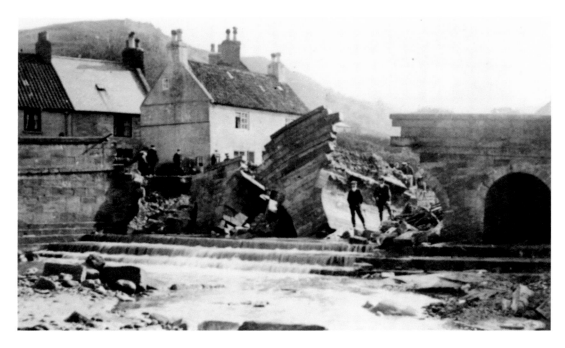

East Row Bridge

The road at Sandsend first crossed East Row Beck or 'Estbeck' as it was first recorded. The waters of East Beck are partially tidal to just beyond the opposite side to the ocean. The present bridge is a replacement for a three-arched stone edifice that was washed away during a storm on 20 May 1910. Debris blocked the narrow arch and restricted the water's flow to create a huge mass of water that eventually put so much pressure on the stone work it crumbled and broke up.

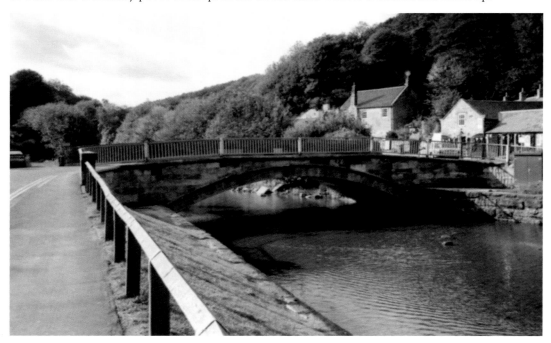

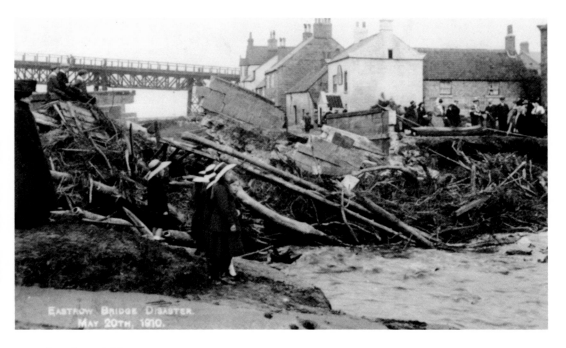

East Row Bridge

From the landward side it is possible to see the stupendous amount of debris that washed down and came to rest against the stonework of East Row Bridge. It is no wonder that it reached breaking point. Note the schoolchildren in smart uniforms, suggesting that they had made a special journey from Whitby; the headmaster in old-fashioned mortarboard is keeping a watchful eye over his charges. Below, the inscribed stone carrying the badly eroded inscription 'of East Row' still survives built into the parapet of the present bridge.

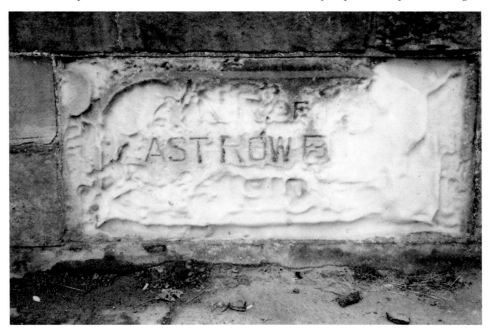

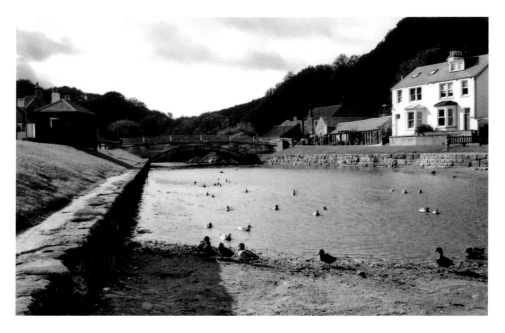

East Beck, 2011

Two views of East Beck showing above and below the bridge. A flock of ducks has been present here for as long as I can remember, growing fat on the litter of untidy holidaymakers. In winter they migrate inland – or south to foreign climates – with the full knowledge that when they return there will be rich pickings for the ducklings. In the distance to the right can be seen the former stables on the roadside, which have recently been converted by the Mulgrave Estate into modern retail units.

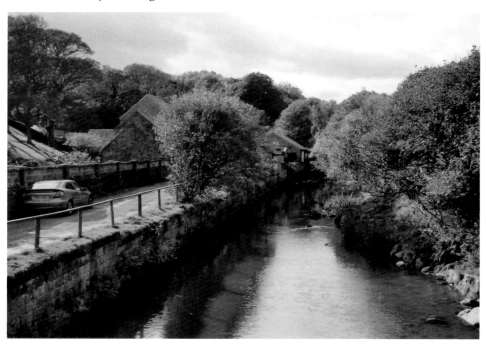

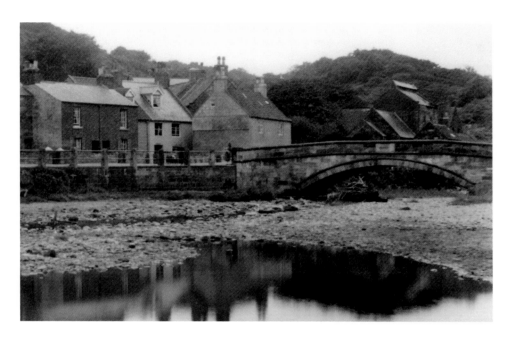

East Row, *c.* 1910

A horse and cart trundles along the road toward the recently opened East Beck Bridge, while below the scene shows the old three-arched bridge before it was washed away in floods. The Hart Inn can be seen, and the house adjacent but set back is now the Estbeck restaurant. Immediately below is the roof of the old cement works, and on the very right-hand edge of the photograph the large property with a central gable is part of the Sandsend Brewery. A great deal of these buildings have since been demolished.

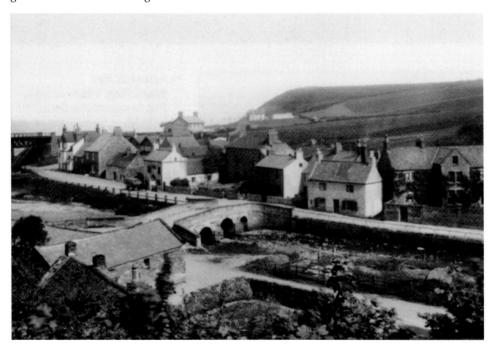

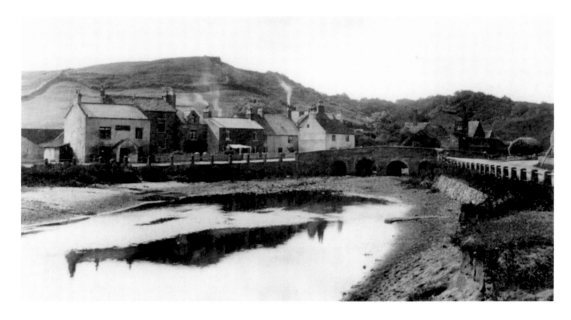

East Row in 1880s

Most of the buildings in this photograph are recognisable today even if their original use has been changed. The bridge of course, is the old structure washed away in 1910. Behind the bridge can be seen the roof and tall chimney of the Sandsend Brewery. Opposite the haystack on the right stood the cement works and kiln, which still survives although empty. Below, the photograph is almost the same view, and the Hart Inn can be recognised, still trading under its name and licence. The viaduct which carried the railway no longer exists.

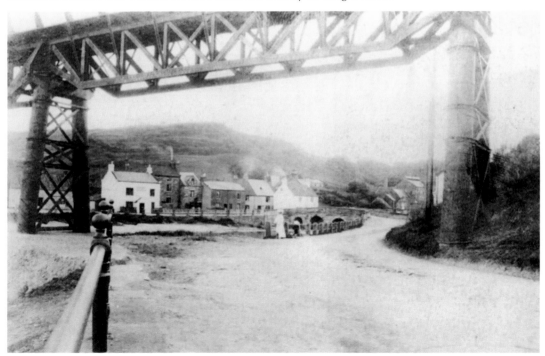

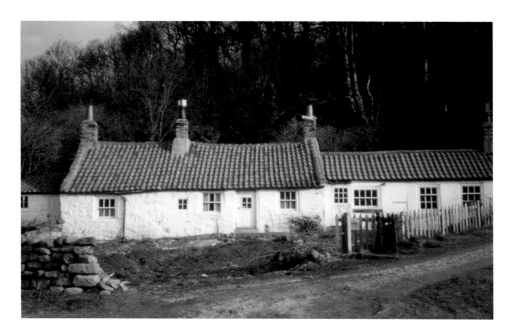

The Old Post Office

This long low cottage with a pantiled roof is now a tearoom known as Bridge Cottage and was once the old post office, staffed by Madge Kirby; before that for a period it was situated in what is today known as Shellstone Cottage, near to Sandsend Court. Prior to 1849, an old woman named Johanna Donkin went every day to Whitby and brought letters back to East Row, where they were thrown into a heap on to a table at the village inn, and subjected to the handling and criticism of every person who chose to rummage among them.

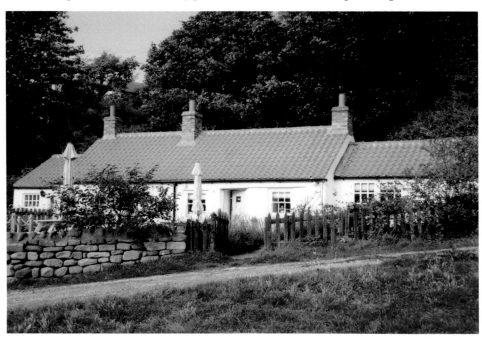

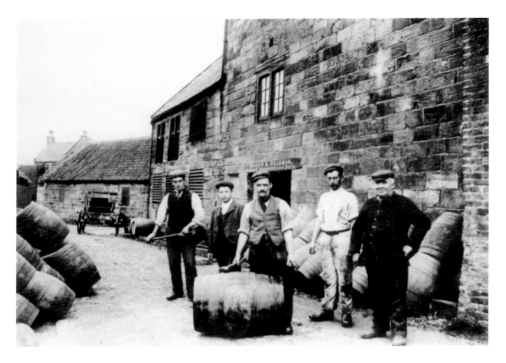

The Sandsend Brewery

Beer was supplied to the local hostelries by the brewers Corner & Readman (above) at Sandsend. Even up the hill to Lythe to the eccentrically named inn The Stiddy – an archaic name for a blacksmith's anvil. At Lythe an old custom of the smith was to take the anvil outside and turn it upside down. The hole on the base was then packed with gunpowder and a wood plug inserted. The gunpowder was set off and the plug shot into the air with a loud bang.

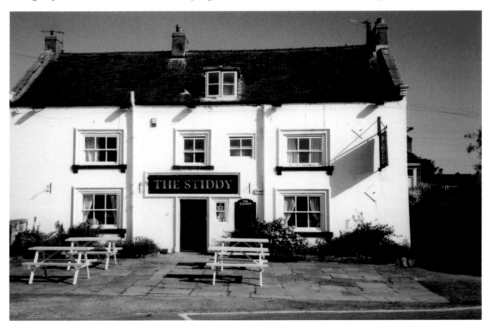

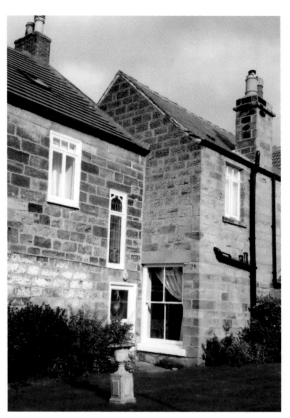

The Hart Inn, Sandsend
The Hart Inn, once named the White Hart, is one of the oldest properties along here, the oldest being the thatched cottage to its left which has mullion windows which suggest a sixteenth-century date for its erection. Behind the Hart Inn, and beyond the thatch cottage, in the rear of the nineteenth-century dwelling can be found this curious window (below) which provides natural light for the staircase. An interesting survival of its earlier period, it has managed to remain despite a number of other windows being replaced by other styles.

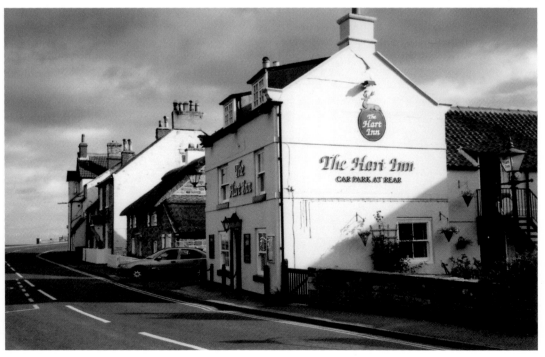

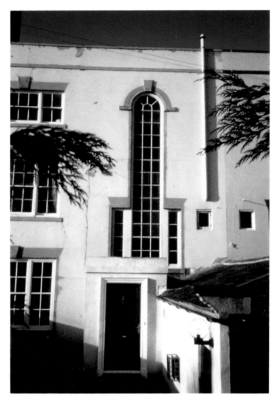

Whitby Windows

Whitby has a tradition of unusual windows; on the left is one of a pair that can be found on Upgang Lane, which today is a main highway to Sandsend and beyond. However, when these properties were built they fronted onto the road behind Stakesby Vale, and this is the side that the staircase windows were found. However, as Upgand Lane grew in prominence, the householders turned them around so they now front onto Upgang Lane and porches were added as 'front doors' cutting across the window bottoms. On Grape Lane, below, the tallest window in England can be seen – known as a 'bottle window' from its shape. Whitby has the highest number of these in any Georgian town in the country. The reason why they exist is due to the character of the Yorkshireman. At the time of the Window Tax, which taxed a property on the number of windows it had, while many houses had their windows blocked up to save money, in Whitby the folks put up one long window through three or more storeys of staircases, that way they only got taxed on one window, but had light for the entire height of the stairs – a canny way of saving brass!

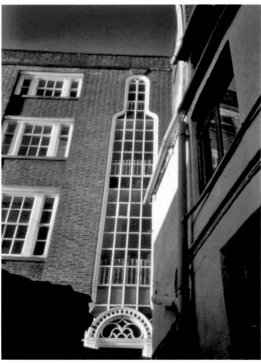

Sandsend Brewery

Many a village had its own brewery, and while some disappeared into oblivion, others prospered and became nationally known brews. Others achieved a modicum of success and served a reasonable area but later died away. The brewery at Sandsend stood along the beckside nearby, and no doubt supplied the early landlords of the Hart Inn. In its earliest period Linton Brewery operated here for many years, and in 1890 Corner & Readman took it over and began their brewing operations from here with a warehouse on the corner of Marine Parade, Whitby. Although a clothing store it still retains a loading door on the second floor and hoist above. In 1931 the Scarborough & Whitby Brewery took over Corner & Readman and continued to brew here for some years after. They also owned the Sandsend Hotel for a number of years. Today the brewery building survives, but as a house, and is still recognisable with its warehouse doors. Nearby on the garden wall of the former Sandsend Hotel can be seen this head made from shells. Perhaps it is the head of Neptune, the sea god; or is it Bacchus, god of wine and fun?

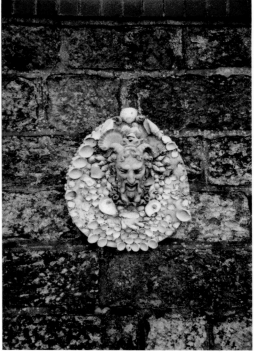

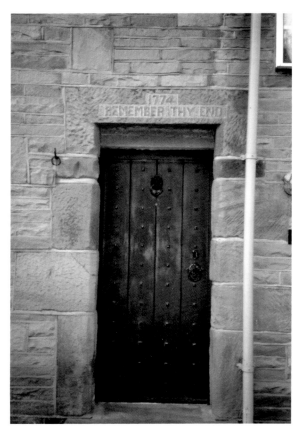

The Brewery Courtyard

All these properties within the old brewery courtyard would have served the brewery, but today are now housing. One building, dated 1774, and named Daneholm, was once the home of Dora Walker, FRSA, the first woman in the country to hold a Skipper's Licence; she was also for some time curator of Shipping Records and Models at the Whitby Museum, Pannett Park. She was also the author of a very interesting book on the sailing vessels of Whitby. Even today the road remains rough without a tarmacadam surface.

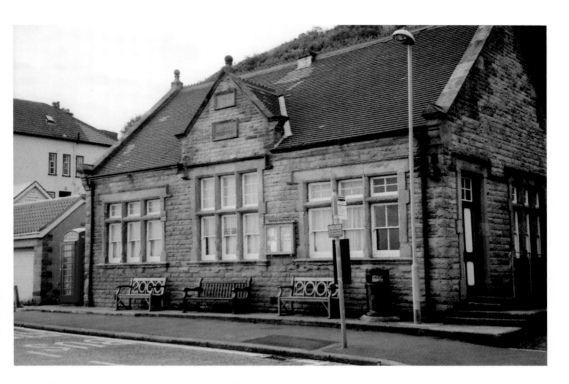

The Pyman Institute and Sandsend Stores

In 1900 George Pyman of Raithwaite Hall died. Before his death he begun for the benefit of the village the institute erected on the site of the cottage where he was born. Not finished until after his death, under the foundation stone was placed a sealed bottle containing a slip of paper on which was inscribed: 'This corner stone of the Pyman Institute, built by George Pyman, of Raithwaite, on the site of the house where he was born, kindly given by the Marquis of Normanby, was laid by Mrs Walter H. S. Pyman on the 21st day of June 1900.'

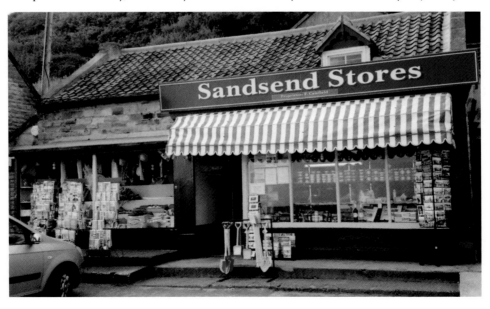

The Promenade, East Row

Along this part of the seafront the architecture is mixed. Old cottages are sandwiched between modern boarding houses from the 1920s and '30s. Some older buildings have interesting stories. Behind the Pyman Institute stood a thatched cottage where a John Stonehouse was born, an alum worker in Sandsend and great-grandfather of Gordon Stonehouse of Pear Tree Cottage, The Valley. John Stonehouse had a son, Henry (*b*. 1868), who was a cement worker at East Row. Henry and his wife Eliza Jane had nine children who survived, and four who died in infancy.

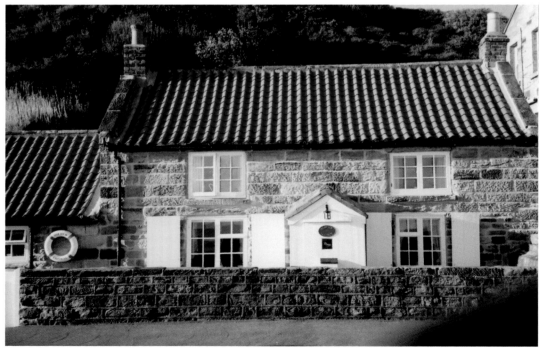

The Promenade, East Row

A busy summer scene with people strolling and carrying wicker shopping baskets. The man in uniform, possibly the stationmaster on an errand, is chatting and men are idling their time sitting on walls. Nannies are taking children for a stroll, a horse and gig with its passenger out for a ride, and amongst them all a hen struts its way across the road. The alum works can be seen at the end facing down the street, and today, the distinctive two gabled cottages remain unchanged, no doubt plying its trade as a boarding house, then as now.

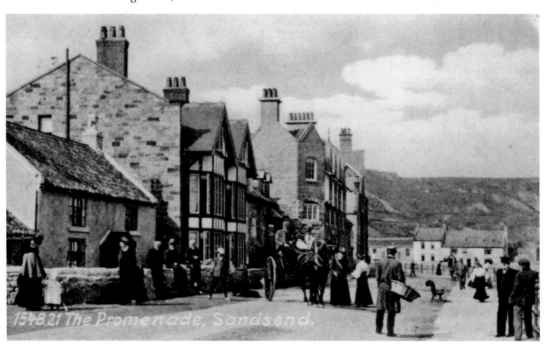

1548.21 The Promenade, Sandsend.

Ancient and Modern

In one respect, along this part of Sandsend it could be said to resemble a Wild West 'one horse' town, usually meant as a description of a place with only one street of housing. So it is for the most part, but toward the end are a couple of alleys that run back to yards full of houses and more. In these yards time stands still, but occasionally you can find a surprise, as here in this modern entrance to a yard, skilfully crafted in metal and carrying a design representing the rolling waves casting spray – an apt solution to a perennial problem of rotting wood corroded by saltwater. As it weathers it will no doubt look even more distinctive. Indeed, the surf hereabout often flies high overhead and splashes down on the roadway especially in wintry conditions, and as a driver it is a delight if not a naughty indulgence to cruise along letting the waves fall from above.

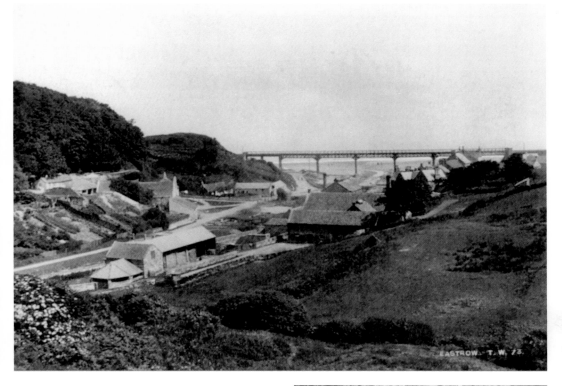

The Cement Works

A Tom Watson photograph taken in 1919 showing the old cement works on the extreme left. The cement produced here went under the name 'Roman cement' and as a child I misunderstood and thought the empty works had been here since Roman times! However, in adulthood I am better informed, and am aware that Roman cement was made from nodules found in the alum shale and had a peculiar property of being able to dry in wet and damp conditions. Therefore it was found useful on marine constructions like piers, lighthouses, etc. Below the pit which housed the water wheel that drove the machinery.

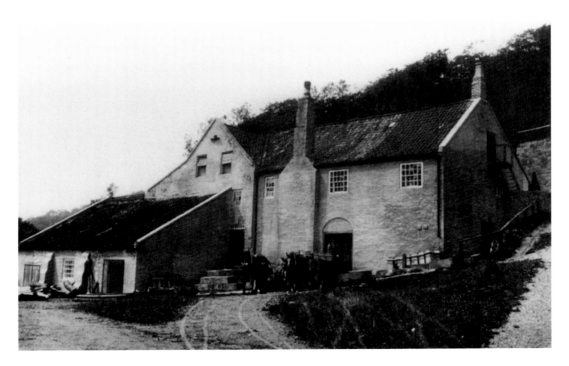

The Roman Cement Works

Photographed in 1889 when still in operation, the works provided a welcome source of employment to the men of the district, especially after the collapse of the alum works. The building itself began life as a water-powered corn mill, and the empty wheel pit still survives. Undoubtedly dating from the early eighteenth century, in the next century it ceased grinding corn and became the Roman cement factory. Roman cement was, and still is to some extent, used for its ability to cure quickly underwater, and is invaluable for harbour works where tidal water dictates the drying time.

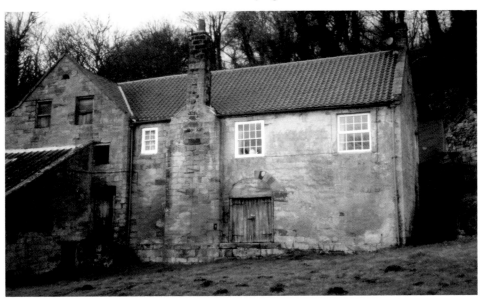

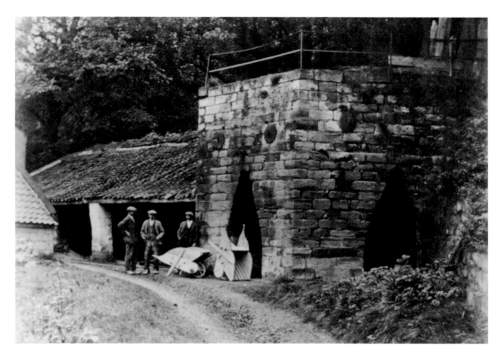

The Cement Work Kilns

Behind the building stand the remains of the cement kilns with their narrow pointed-arch flue openings, interesting relics of a past industry. The cement works operated into the first quarter of the twentieth century. The unusual type of wheelbarrow was employed to carry away a measured amount of cement. Although currently derelict, no doubt the Mulgrave Estate will find a use for it as they renovate the buildings under their ownership.

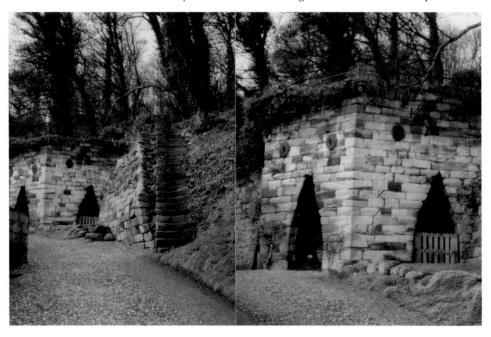

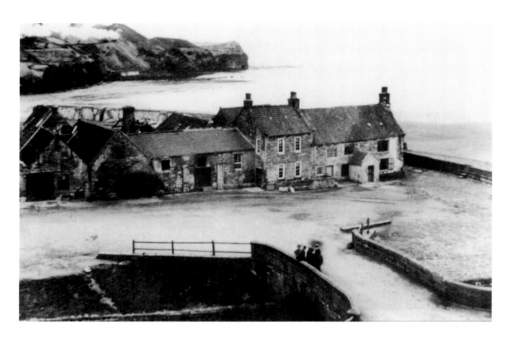

The Alum Works

A view showing the alum works as they stood around 1920, long after it had ceased production. The right-hand cottage and house were destroyed by a drifting sea mine during the Second World War. The building to the left was pulled down except for the front walls (below), which lead today into a large municipal car park which covers the area of the former works, the buildings of which were demolished. The production of alum gave employment to numerous men both local and itinerant from the 1660s until the 1870s.

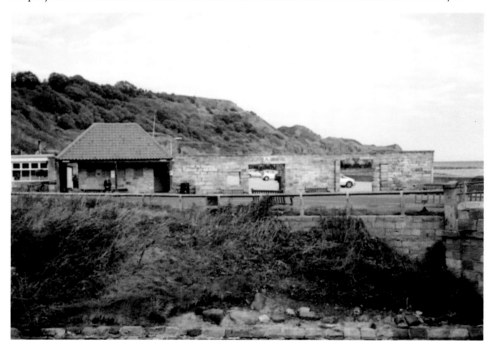

Relics of a Forgotten Industry
Little survives of the former alum works;
above a plastered wall is all that remains
of a small office for the wages clerk.
Below, outside is an old mounting block
to aid visitors in mounting their horses.
Below right is a much-weathered stone
with an illegible inscription. The local
sandstone glows golden in the evening
light and over the years has no doubt
contributed to the lovely sands hereabouts
on what is Yorkshire's own Jurassic
coastline. The earth often reveals the
remains of prehistoric monsters.

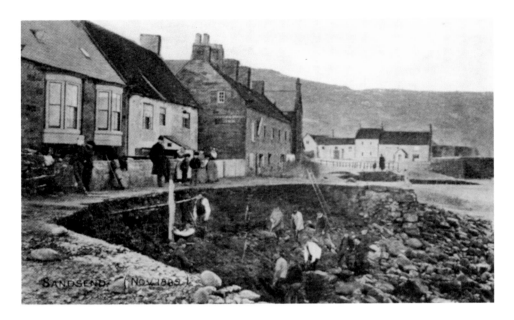

Storm and Tempest

Above, spectacular damage to the coast road at Sandsend in November 1889, following a pounding by heavy seas. Below, almost the same location but after a storm in 1902. Facing toward the camera are the cottages and entrance to the old alum works, and of course, the bend leads to Lythe Bank. The top photograph is another superb view by Lythe photographer Tom Watson. This particular stretch of the coast is prone to the effects of storm and tempest; indeed, the cliffs around here are crumbling away at the rate of a foot per year.

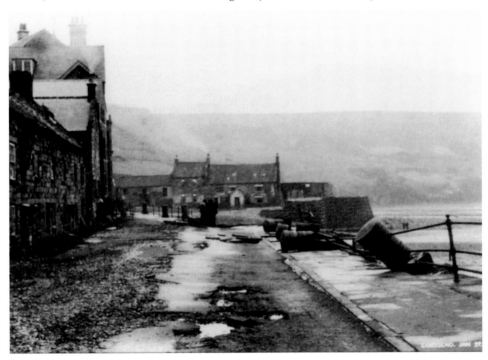

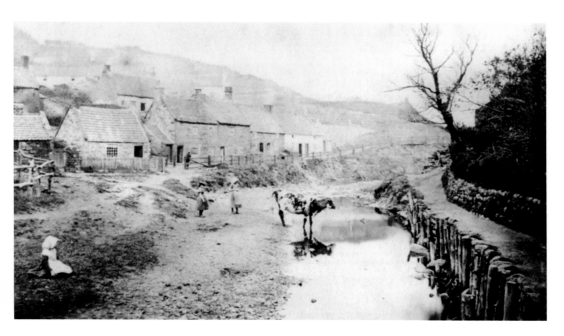

Sandsend Beck, *c.* 1860

A posed photograph showing the valley through which Sandsend Beck flows. A rural idyll which almost remains today, the image conveys a sense of tranquillity which must have been greatly disturbed twenty years later when the 'iron horses' clattered over the viaduct that spanned the gorge. Many of these properties I notice belong to the Mulgrave Estate and have been renovated in the last decade with, no doubt, an appropriate increase in rents.

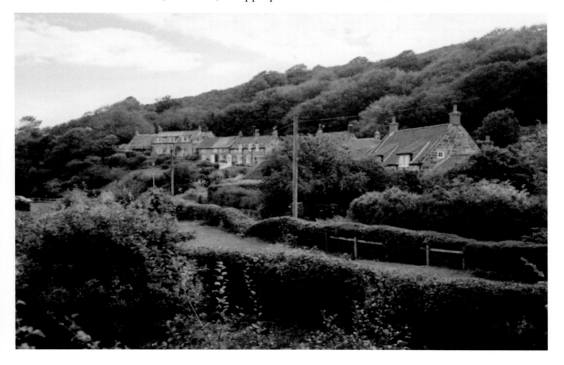

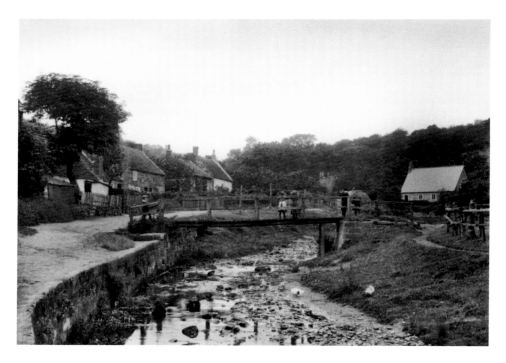

Sandsend Beck and Church

The valley of 'Sandebeck' leads to St Mary's church. The parish was served by St Oswald's at the top of Lythe Bank but, in 1869, a chapel of ease was built as a convenience to the residents. In 1909 St Mary's received a new chancel, although plans for much more extensive works exist. During the restoration of Lythe Church in 1910, marriages for the district were performed under a temporary licence at St Mary's which, in 1999 under a grant from the Archbishop of York, became permanent, and the first wedding took place in 2000.

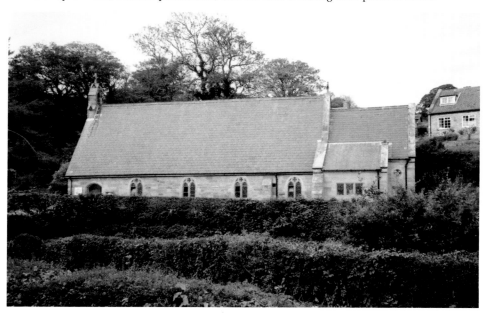

Church of St Mary, Sandsend

Opened in 1870, the original design was for a single space enclosing both nave and chancel. Internally, it shows the influence of an Early English style of architecture, and is unfussy. However, as the parish grew it became evident that there was a need for more room for the growing population and visitors, and with this enlargement some improvement and reordering of the interior. The east window is in the decorated style of the fifteenth century, while the west window in its three lancets echoes the east window of Whitby Abbey.

In the late-nineteenth century a Methodist Chapel was built by the Wesleyan congregation in Sandsend, using stones collected off the beach, and when finished it could seat 150 persons. In time, the chapel at Sandsend acquired a reputation in the district for its Harvest Thanksgiving Services and tea.

Lionel Charlton in 1777 asserts that an ancient hermitage stood at the village now called Eastrow: 'Here, stood the idol temple of the heathen god, Thor, from whence the place was for many centuries called Thordisa [the name of Thor's wife]. The sacrifices that have been made, and the worship that was paid by the Romans in *Mars*-dale, near Sandsend, were afterwards, on the arrival of the Saxons, transferred a little southerly to the village of Thordisa. Here the place of worship appears to have been fixed by the heathens, till Christianity did prevail...'

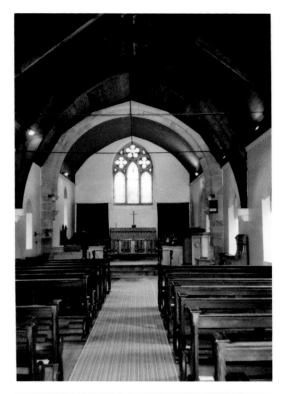

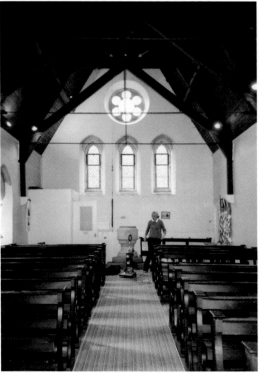

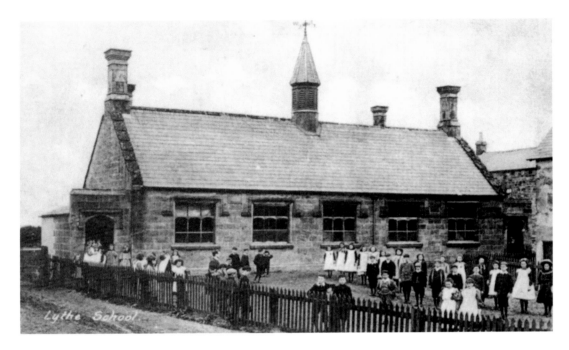

The Village School

Sandsend had no school of its own, but many children ascended the hill to Lythe, as they do today. This school was built in 1819 and enlarged in 1872. A Mr Crowther, aged twenty-one, came from Almondbury near Huddersfield to be headmaster in 1861. He was recorded as being 'dangerously ill' in October 1902 (*d.* 1903) and he was replaced by William Edward Irlam. The school was replaced by the new Lythe Church of England primary school which was officially opened on 19 April 1977 by Lord Normanby. There were ninety-six children on the school roll and four teaching staff.

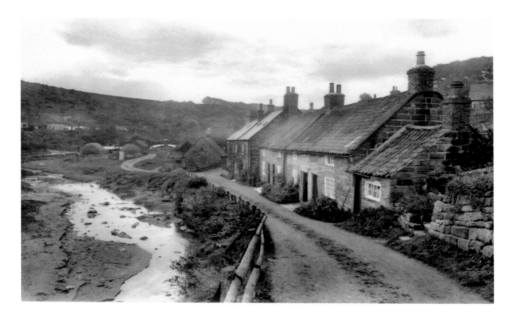

Low Row, Sandsend

Many of the cottages along Sandsend Beck are of great age and antiquity. Glen Cottage, for instance, was occupied by the McLean family since the 1700s, and six generations inhabited the property until 1978, 'ending 223 years of McLean occupation'. Doctor J. Fraser from Whitby held a surgery twice weekly at Fern Cottage, and Doctor E. F. Tinley MD, had his practice at The Haven for many years followed by Doctor C. Mason MD. Today, a new surgery stands at the bottom of Meadowfield on the main road, where Doctor Ian Suckling MD attends.

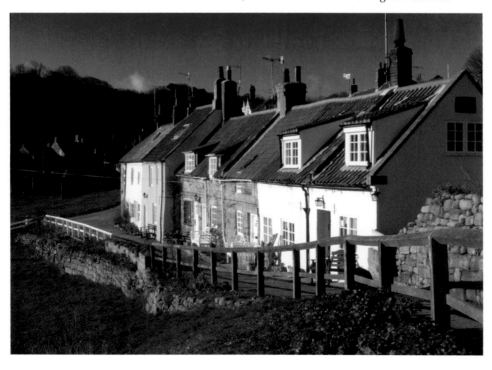

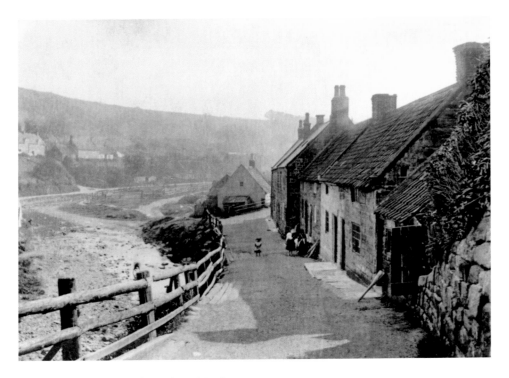

Low Row Cottages and Sandsend Beck

Two more views of Low Row Cottages and Sandsend Beck, this time from a little further along toward the main road. Undoubtedly at one period these properties would have had a thatched roof covering, however, many houses of the district from an early time had pantile roofs, shipped into Whitby as ballast from vessels trading with Holland. These were considered 'cheap', but nevertheless builders made use of them, and today we are glad, as they have a warm and mellow glow and add to the landscape.

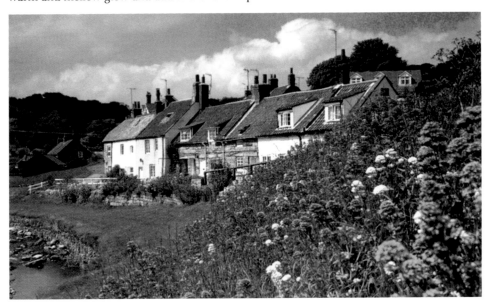

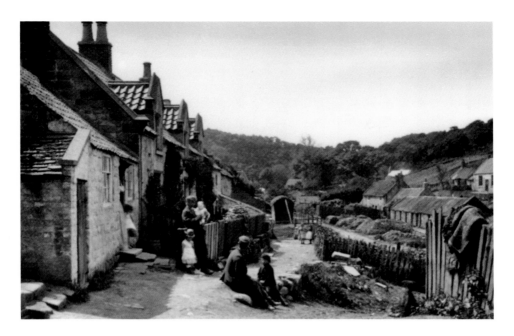

Tea Pot Hill, Sandsend

The first two cottages above were together known as 'Rockery Cottage'. However, to distinguish them from each other one was named 'Big End' and the other 'Little End'. They have since been converted into one dwelling. Today, Michael and Carolyn Russell live at Mount Pleasant, Tea Pot Hill, Sandsend. Michael's wife's mother was Esther Bunn *née* McLean, born at Primrose Cottage on Tea Pot Hill, before moving to Glen Cottage. Carolyn Russell's maternal great-grandfather was one Captain William McLean and he owned a coal boat that plied a trade along the East Coast.

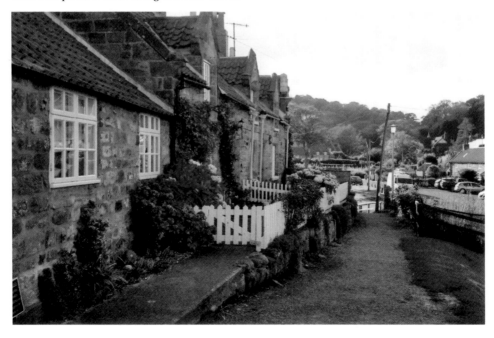

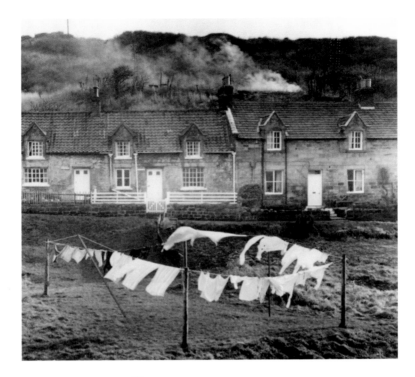

Wash Day, Teapot Hill

A terrace of estate cottages, erected for workers on the Mulgrave Estate and conspicuous by their 'sameness'. The first cottages along Teapot Hill are of early date, some from the sixteenth century, and have blocked up mullion windows on the upper floors. It is possible from the number of windows and from their spacing that these were possibly weavers' cottages, where the looms were upstairs in order to catch the light for as long as possible, as there was no electricity. This arrangement of windows is particularly common to the West Riding woollen areas.

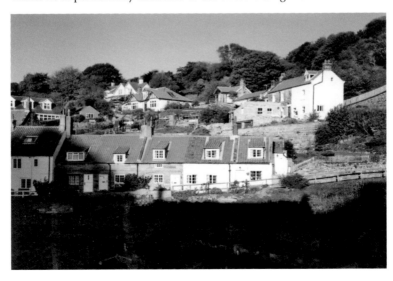

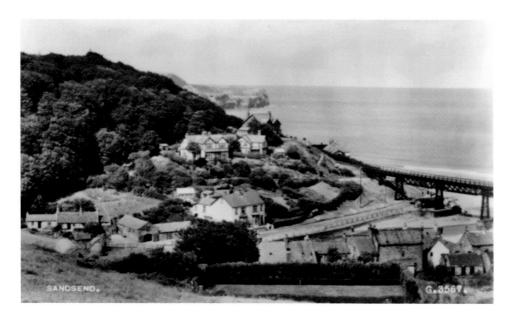

The Alum Works

A view across Sandsend Valley towards the sea; below left the extensive alum works can be seen. Also conspicuous is the iron-girder viaduct that carried the railway across the valley, and at the end (left) can just be seen the Sandsend railway station. Below, the station buildings peep over the cliff, but the photograph was taken to show the massive stone abutments of the viaduct. Correspondingly, on the other side of the valley, at East Row, the other massive stone abutments survive, which today act as buttresses for the falling cliff.

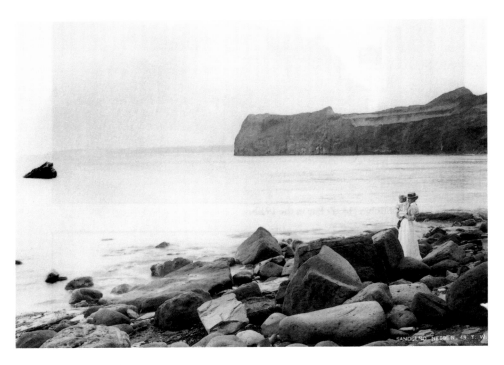

A Wave by Any Other Name

Here, an Edwardian lady and child on the beach on the Staithes side of Sandsend Ness gaze out to sea; a haunting and evocative picture. The cliffs of Sandsend Ness show the ravaging scars of centuries of alum working. Indeed, further along the coast the mining below ground was so extensive that it undermined the village of Kettleness, which tumbled into the sea in the nineteenth century. Of interest, the North Sea was previously known as the German Ocean, and the name was changed in atlases at the time of the First World War.

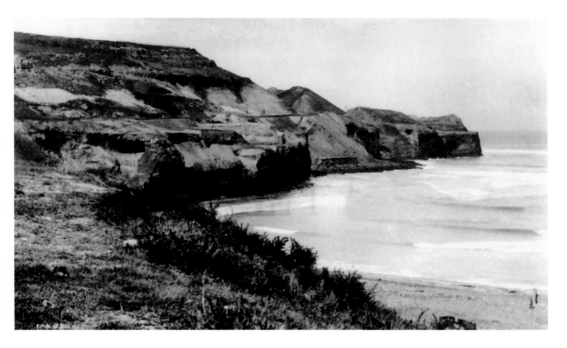

Alum Mining at Sandsend

The consequences of Britain's first labour-intensive industry, alum mining and manufacture, can be seen in these photographs by Sutcliffe, the top one taken around 1880. Here we can see the scarred cliffs, which have been mined since 1607. The alum workings then continued until about 1870, but the manufacture of Roman cement took over around 1811 utilising the spent waste, which was then carried on until the beginning of the twentieth century. In the top picture can be seen either a small staithe for mooring ships for loading, or bagged alum awaiting collection.

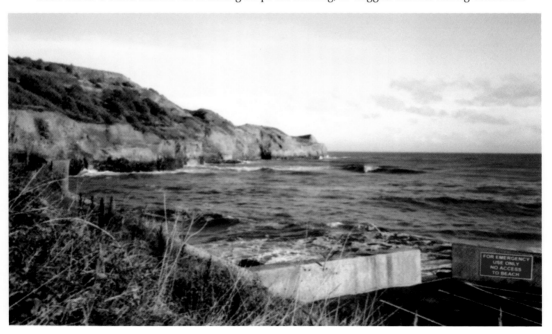

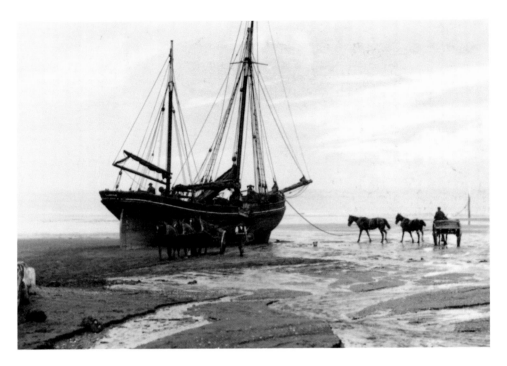

Ship Ahoy!

Unloading coal direct from the boats was common practice before the coming of iron steam ships and, as a consequence, locally built vessels had a flat bottom for beaching, and were called 'cats'. The *Diamond* was owned by Captain William McLean of Sandsend and carried coal from either Blyth or Hartlepool. Here it is seen on Sandsend Beach. About this time, in 1887, best household coals cost 14s per ton. Below, the ship *Lucy*, a Swedish vessel that ran aground on 28 December 1930 and was finally burnt out at Sandsend on 22 March 1931.

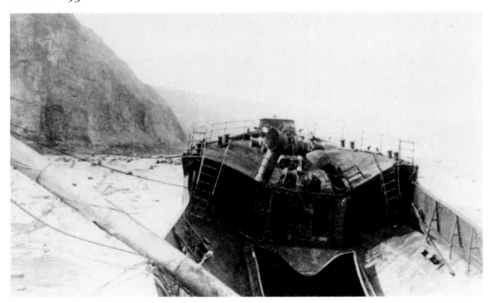

Captain Cook and Seamanship

The bronze statue of James Cook, 7 feet 6 inches high, is the work of John Tweedy, and was commissioned by Gervase Beckett MP, and unveiled on 12 October 1912. The 20-foot-high plinth on which it stands, of local stone, is decorated with a relief model of the *Resolution*, one of the Whitby-built ships that carried Cook and his crew on their voyages. It was set up to commemorate the endeavours of the man and the crew. Below, a painting of the *Earl of Pembroke*, leaving Whitby; the *Pembroke* was renamed *Endeavour*.

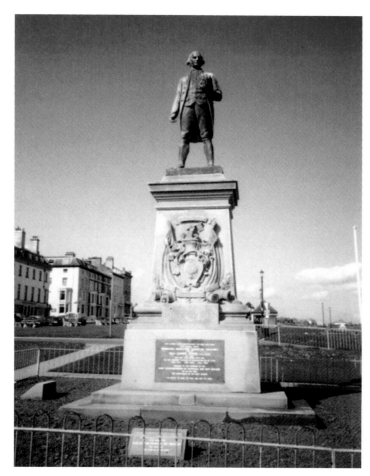

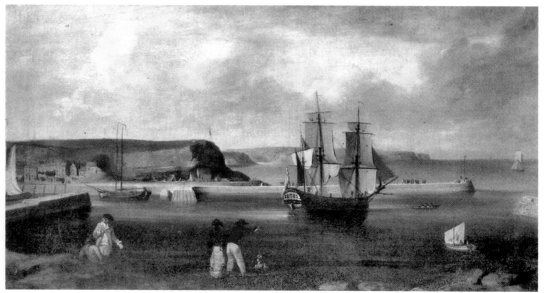

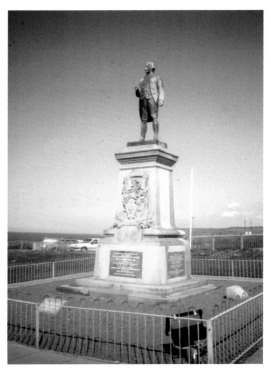

The Cook Memorial

The plinth also carries on each side a bronze plaque: one given by the people of New Zealand dated 2 April 1984; one given by the people of Canada on the 250th anniversary of his birth in October 1978; another by Australia on 20 April 1970; and a fourth which reads:

'This plaque is to commemorate the men who built the Whitby ships *Resolution*, *Adventure* and *Discovery* used by Captain Cook, RN, FRS and also the men who sailed with him on the greatest voyages of exploration of all time 1768–71, 1772–75, 1776–78. Unveiled in the presence of the High Commissioners of Australia and New Zealand on 26 April 1968, the bicentenary of his first voyage. – To strive, to seek, to find and not to yield.'

A number of the brave souls that crewed these ships on their perilous voyages came from Sandsend and the erection of this statute is as much a testimony to their skill and determination to succeed as it is to the character of Captain James Cook, who before finding fame crewed a humble collier vessel delivering coal around these home ports, which no doubt included Sandsend.

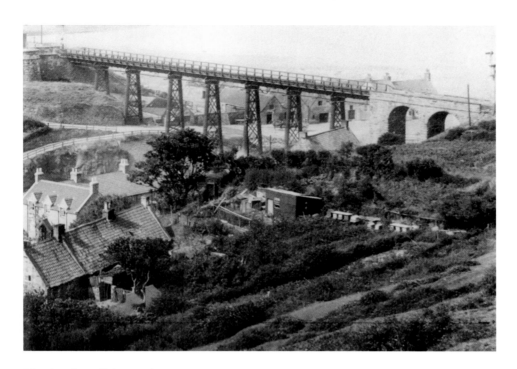

The Coming of the Modern Age

The railway dominated Sandsend for over three-quarters of a century; in particular the two viaducts that crossed each of the valleys were both impressive and conspicuous. Officially designated the Whitby, Redcar & Middlesbrough Union Railway, it was opened in December 1883 after a difficult and protracted period of construction. The enterprise began at Whitby, running from West Cliff Station with halts at Sandsend, Kettleness, Hinderwell, Staithes, Grinkle and Loftus. From here northwards, trains normally ran via Guisborough to Middlesbrough. The line was single track with passing points at some of the stations.

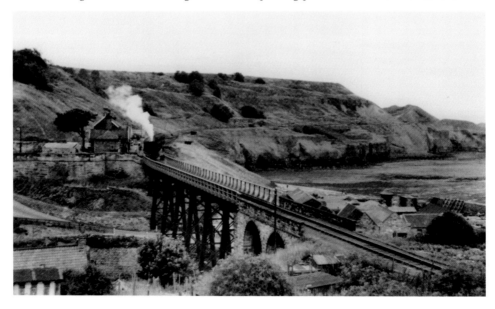

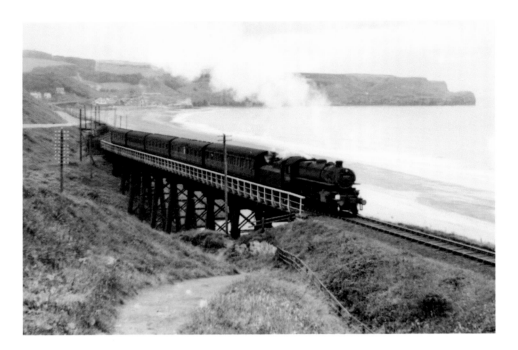

The Coastal Route – Now Gone

Between Whitby and Kettleness it was necessary to provide four steel trestle viaducts and two tunnels. Sandsend tunnel was just under a mile in length and Kettleness tunnel 308 yards in length. The steel viaducts were situated at Upgang Ravine, Newholm Beck, where the footings can still be seen, East Row and Sandsend, where the viaduct spanned both the road up Lythe Bank and Sandsend Beck, before taking the railway into Sandsend Station. After leaving Sandsend, trains then faced a stiff incline of about 1:57 to Kettleness, which sometimes caused problems.

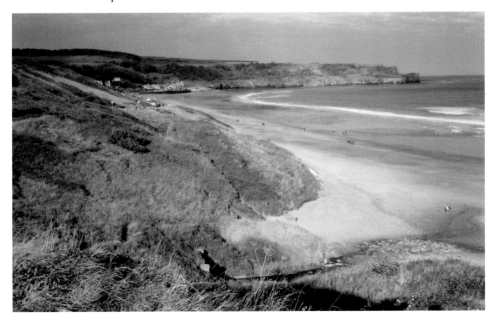

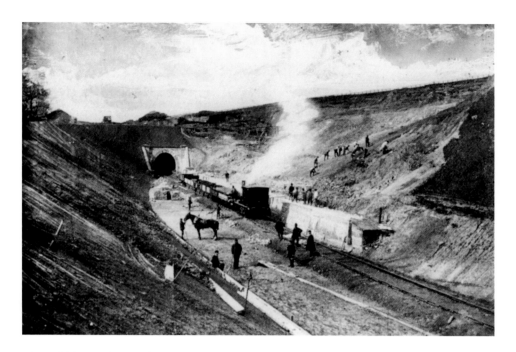

The Whitby–Loftus Railway, 1870 and 2011

The business of completing the coastal railway between Whitby and Loftus began in July 1866 with the incorporation of the Whitby, Redcar & Middlesbrough Union Railway. Raising finance proved difficult and no construction started until 1871. Work stopped in 1874 when the contractor went into liquidation. To complete the railway the company turned to the North Eastern Railway which took a perpetual lease over the route in 1875, but it still took until 3 December 1883 before the 16½-mile route was ready for use. Above we see the newly-built Grinkle tunnel entrance.

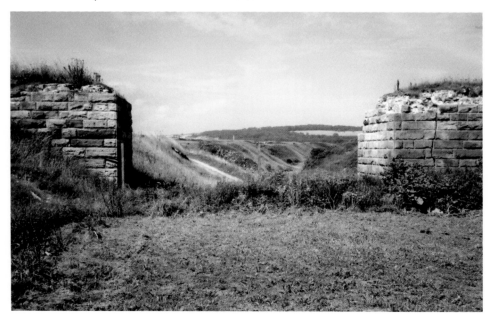

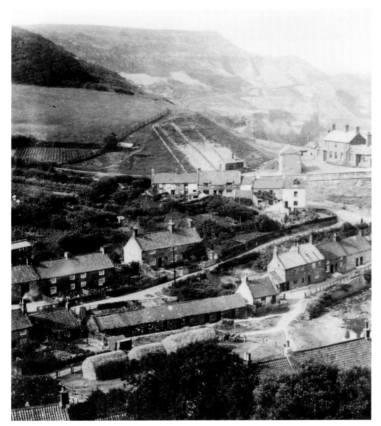

Goods Traffic Along the Line

The railway played an important part in the transport of goods around the area, and later in bringing in tourists, especially in the summer months before and shortly after Second World War. Goods were transported from here for some years after the line closed to passenger traffic. The goods warehouse and yard were situated at East Row (behind where the doctor's surgery stands; now being built on). The main goods handled here were timber and cattle food, and there was a coal yard at Sandsend Station. The top photograph dates from 1883 the year in which the station was opened.

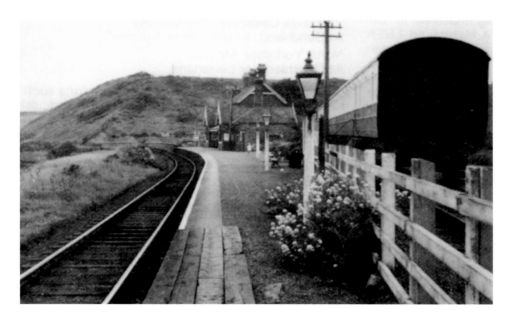

Hi De Hi! Good Morning Campers!

One attraction at Sandsend were the Camping Coaches, of which in 1938 there were two sited at Sandsend and three at East Row. These camping coaches proved very popular and were converted from Great Western Railway (GWR) carriages. They were set up after the Second World War and remained until the 1960s, by which date holiday trends were beginning to change. The coaches below are the ones situated at East Row looking north, with the running line on the opposite side. Interestingly, the Camping Coaches at Goathland Station have been re-introduced such is the demand for nostalgia.

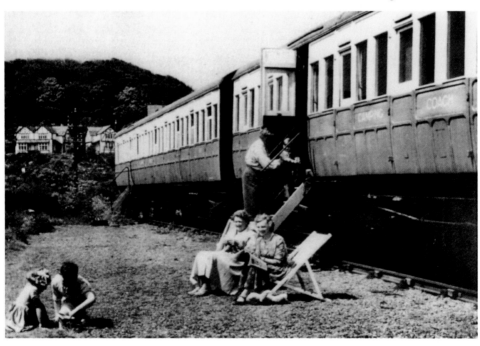

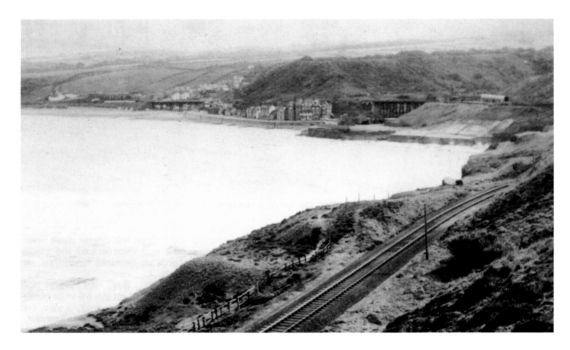

The End of the Line

By the 1950s, there was a steady decline in rail traffic. As a consequence the railways became uneconomical to run and, under the Beeching Act, on the 3 May 1958 the line between Whitby and Loftus was closed with the final engine carrying the ironic headboard 'The Economist'. The last stationmaster to serve under British Railways at Sandsend was Mr C. S. Goodall, who was transferred to here from Ravenscar in 1943. When Sandsend Station closed in 1958 Mr Goodall transferred to Whitby Town Station as a clerk, from where he retired; he died in 1968.

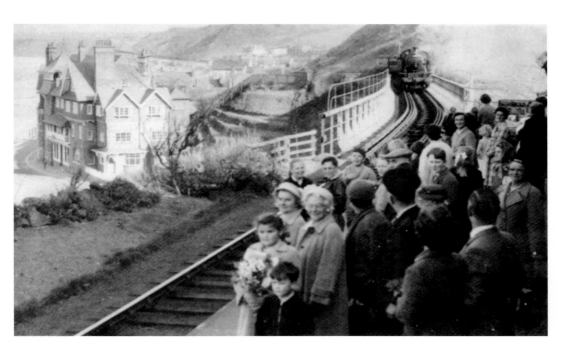

All Aboard for the Sandsend Special!

An image by the Whitby photographer John Tindale showing a small group of passengers and general railway enthusiasts wait to greet the last northbound train on 3 May 1958, which was the 16.27 Scarborough to Middlesbrough railway drawn by No. 67754 a class L1 2-6-4T locomotive. Below we see the platform façade of the Sandsend railway station today, now converted to a family residence, hidden shyly away from prying eyes. A notice on the gate across the former track states 'Private. Mulgrave Estate', which suggests that the estate purchased the redundant station after its closure.

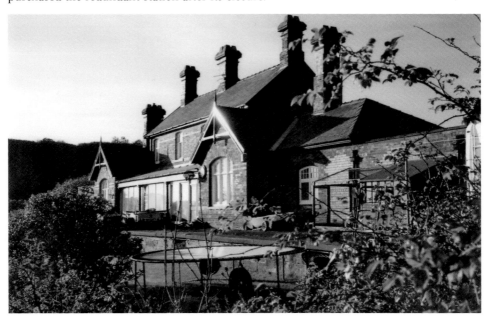

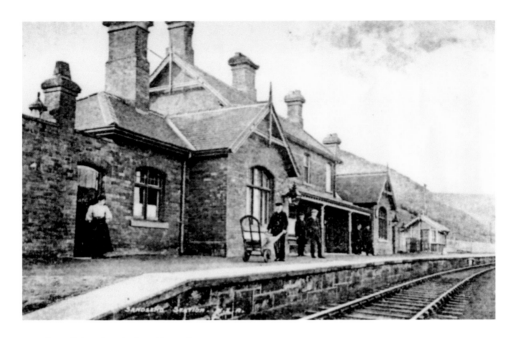

Sandsend Station in its Glory Days

In 1910 there were six trains daily in each direction between Saltburn and Whitby and five between Whitby and Scarborough. Some ran right through with connections to and from Whitby Town whilst others ran from Saltburn to Whitby Town and from Whitby Town to Scarborough connecting with each other at West Cliff. Two of the Saltburn–Whitby workings were advertised as 'autocars'. There were of course additional excursion and relief trains. Sadly, the summer timetable lasted only ten weeks and the railway had to operate way below capacity for most of the other forty-two weeks in the year.

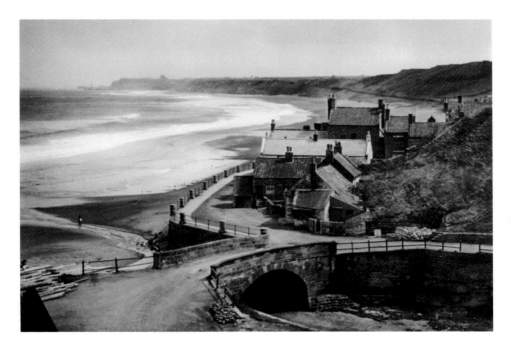

The Mulgrave Timber Enterprise

An unusual view of Sandsend with Whitby in the distance; the lengths of timber on the old Sandsend Bridge are ready for removal to the sawmill. Below, a steam traction engine with a load of logs. In the background are the old cottages belonging to the alum works, which were destroyed by a drifting sea mine that ran against the slipway and exploded during the Second World War. In the early 1950s and 1960s many of these were defused and placed in seaside resorts as collecting 'jars' for various charities established to help the war wounded.

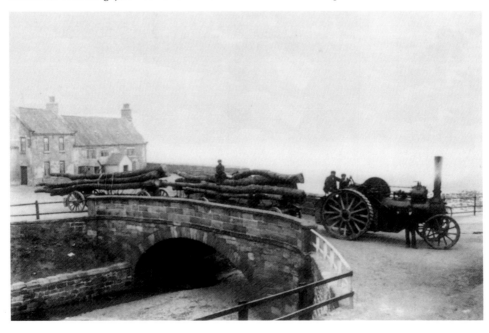

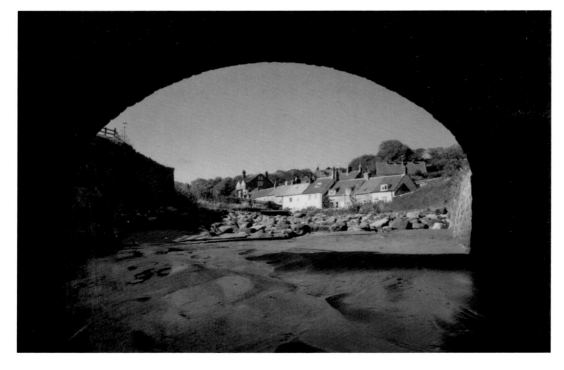

Sandsend Bridge

A view through Sandsend Bridge – the road bridge here, crossing Sandsend Beck, is a replacement for one that was destroyed in some of the East Coast's most memorable floods. A metal plaque secured to the bridge wall about halfway along reads, 'North Riding of Yorkshire County Council – The widening of Sandsend Bridge and the rebuilding of the sea wall damaged by the Great Storm of 1953 were completed in 1955. R. Sawtell, AMICE, County Surveyor.'

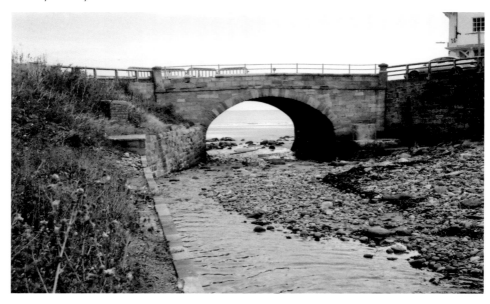

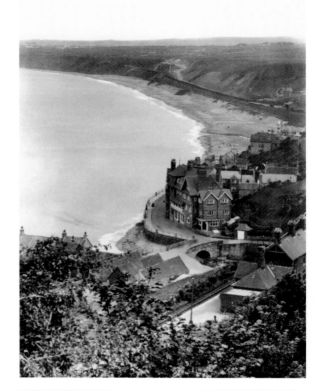

A Pleasant Evening at Sandsend

A visitor to Sandsend penned the following account of a pleasant evening: 'We spent the night at the Beach Hotel, Sandsend, where, in the coffee-room, we met some pleasant people from London, who had been led so far north by the *ABC Guide*. We stayed up till midnight discussing the peculiarities of the Yorkshire and Lancashire character, and while we talked, ever and anon the waves threw their spray on the windows of the room in which we were sitting. The people of the house told us that sometimes in the winter the waves actually dash right over the house and fill the rain-tubs at the back with salt-water. Every one to their taste; but I shouldn't care to live in a house where there was a chance of being washed out of bed some night'. The Sandsend Hotel, the red-brick building on the corner seen here, carries the date 1899 and was originally German-built and owned, and popular with that race as a holiday venue. The building is a nice example of local Arts & Craft Movement architecture from the period 1890–1905.

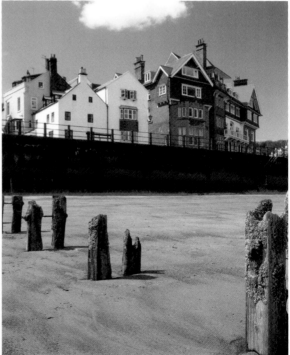

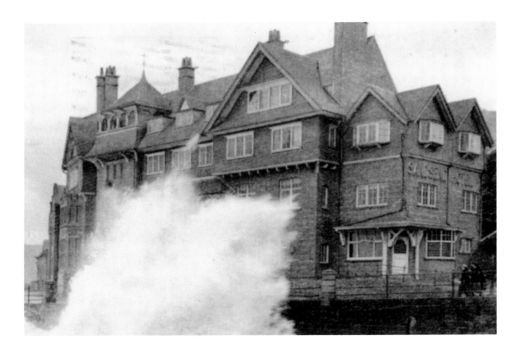

It Was a Dark and Stormy Night

Mention has been made of the terrible destruction wrought by storm and flood, but generally the prospect of Sandsend is a benign one despite the two contrasting images here. Other properties of interest along the front hereabouts include the Beach Hotel, which was previously the George & Dragon public house. The Sandsend Hotel, seen above, was at one time owned by the local brewery Corner & Readman. The manageress in the 1930s was a Miss Newbould. In the bottom photograph, you can just see Lythe bank climbing up above the roofs on the left-hand side.

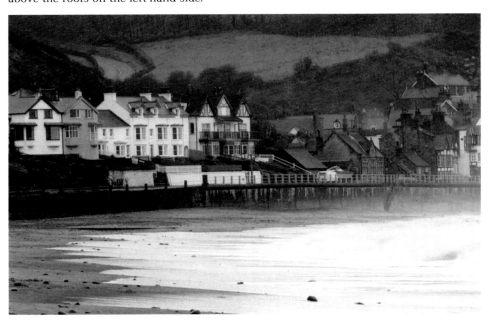

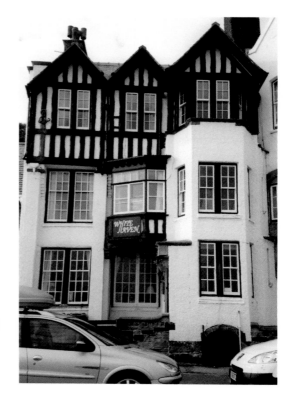

Sandsend Court

Top, is the White Haven Hotel in the picturesque style of architecture popular in the 1920s and 1930s. Of interest is the small door at street level at the foot of the bay; undoubtedly a cellar door. In times past, however, it would no doubt have been of benefit to smuggling. In 1750 no less than four vessels were seized for smuggling but in all cases the boats were released after the fines had been paid. The collector had this to say about Sandsend in 1756: '...the prevalence of vessels coming to discharge and load there and the numbers of workers in the [alum] trade make it difficult to manage [the smuggling] ... the quantities that are landed beggar description ... my officers are tested to put a halt to this ruinous trade ...' Bottom, along this part of Sandsend two small alleyways lead to lesser cottages behind the seafront buildings, and here can be found Smardale House, which was run as a holiday boarding establishment in the late 1930s by a Mrs M. G. McIntosh.

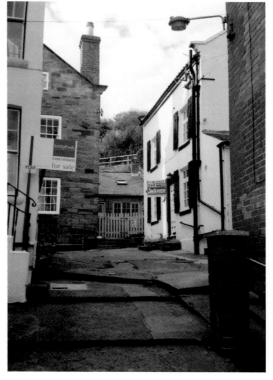

Sandsend Hotel & Garage

Access to Sandsend Court can be gained to the rear of the former Sandsend Hotel, and high above on the brickwork can be seen the original advertising display lettering. More intriguing is the next bay along, which proclaims 'Sandsend Motor Garage'. One can only assume that what now is a rise of shallow steps previously did not exist, thus enabling vehicles to be driven up and around the property. Elsewhere, other properties include Estbek House, believed to have been erected between 1770 and 1820, possibly as a residence for the manager of the alum works, who had his office here as well. However, for the greater part of the twentieth century it was a boarding house, run by a Miss Brunton in the early 1960s until her death in 1973. She was a somewhat eccentric character who worked at one period for the Admiralty at Estbek House. Her guests were by 'invitation only'. In April 1995 Stephen and Janet Cooper continued the tradition of Estbek as a boarding house, and provided cream teas in the garden. Five years on they had developed Estbek House into a hotel and restaurant. In February 2004 Tim Lawrence and David Cross took over and much improved the facilities, making it into superb visitor accommodation and the first and only two-star AA Rosette restaurant on the Yorkshire coast.

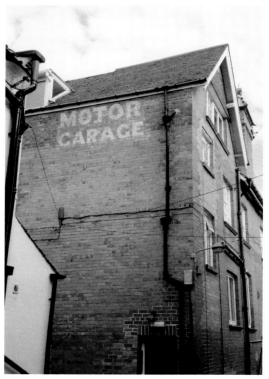

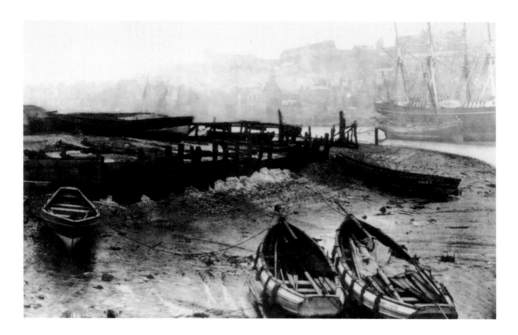

Danger, Craftsman at Work

Another boat builder in the district was Tony Goodall, who established a boat-building business in the former railway goods warehouse at Sandsend. During his time of operation in Sandsend, a total of 187 wooden vessels were built, of which over forty were traditional Yorkshire coble boats similar to above, and whose ancestry dates back to the longships of the Vikings. The boats above are moored to the rotting stumps of the slipway to the Fishburn shipyard (later Broderick's shipyard) which last saw a ship launched in 1862.

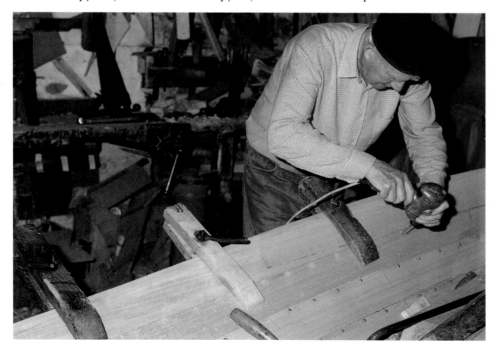

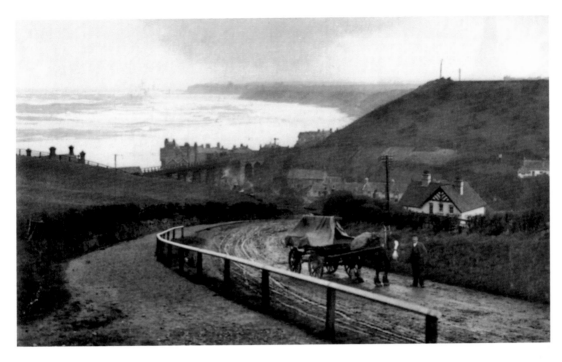

Lythe Bank Looking Over Sandsend

Lythe Bank is a steep and twisty 1:4 gradient hill rising from sea level at Sandsend to a height of 500 feet and the village of Lythe. Difficult for a horse to manage in dry weather, in the winter months it must have proved unassailable. However, the real problem with a horse and cart would be coming downhill and it was often necessary to yoke the horse to the rear and for the men to insert strong wooden poles into the wheel spokes to act as brakes when a cart ran away.

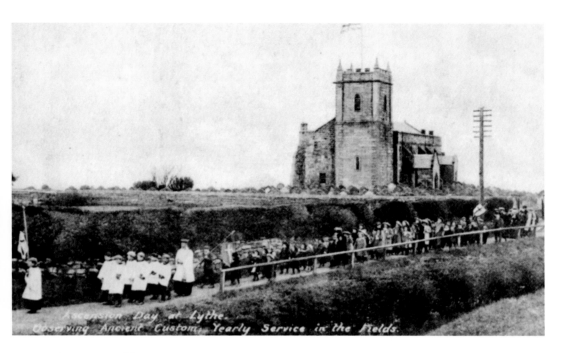

Ascension Day at Lythe.
Observing Ancient Custom, Yearly Service in the Fields.

Lythe, St Oswald's

Those leaving Whitby via Sandsend by road toward Teeside will be familiar with the steep road known as Lythe Bank which arrives at the village of Lythe. Its parish church of St Oswald goes back to Saxon and Norman times but in 1910 plans were put in hand to rebuild the old church above. The foundation stone ceremony for the new church below took place on 29 September 1910. Built to the design of Sir Walter Tapper it was officially opened on 9 October 1911.

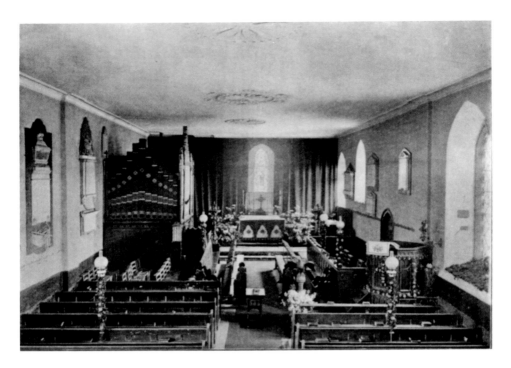

Church Interior Before 1910 and Lady Chapel

Above we are looking towards the altar in the church of St Oswald before the rebuilding in 1910 with its flat plastered ceiling typical of the Georgian era. The chancel was cramped, almost filled with the organ, and it was no wonder that plans were put in hand at the instigation of the third Marquis of Normanby. Below, the Lady Chapel is beautifully proportioned and has splendid vaulted ceiling. The south window is a war memorial to the Old Boys of Mulgrave Castle School. The east window has a representation of St Oswald.

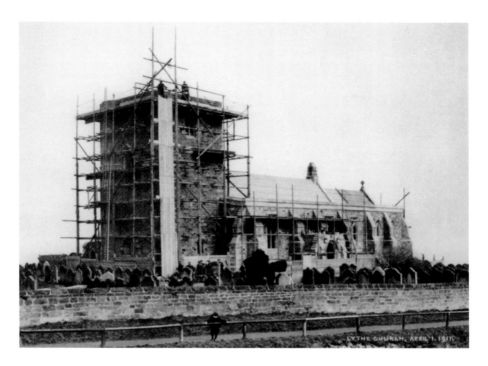

Lythe, St Oswald's

The church during the rebuilding taken in April 1911 when almost complete. Having decided to use much of the old material, during the careful demolition of the church thirty-seven Anglo-Scandinavian carved stones dating mainly from the tenth century were discovered. These Viking stones, mostly funeral monuments from a Christian graveyard, form one of the largest and most important collections in the country. They were cleaned and conserved by the York Archaeological Trust in 2007 and a selection was put on permanent display in a specially designed exhibition at the west end of the church in 2008.

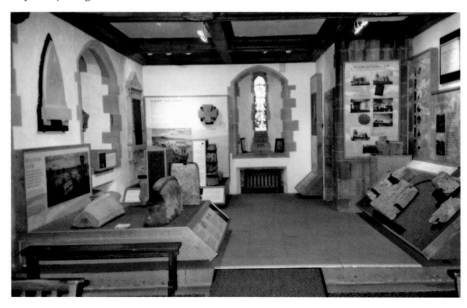

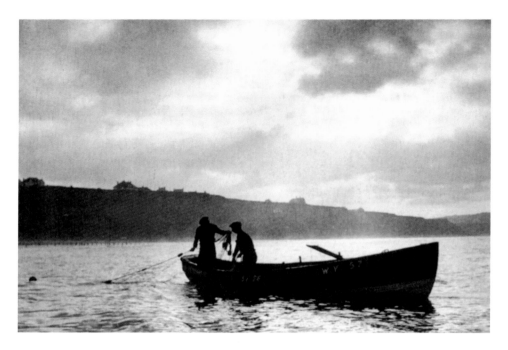

The Boatyard of Richard Cole, Lythe

At Sandsend there was a small fishing fleet, and the traditional coble boat, seen above at eventide in Sandsend Bay, was probably built here in this boatyard at Lythe. A coble was a design taken from the Viking longboat, having a high freeboard and a narrow-shaped stern. The small fishing vessel with a pointed stern was known locally as a 'mule'. These were particularly favoured on this part of the Yorkshire coast were they had to be launched from flat beaches as being 'two-ended' they could be easily manoeuvred in an angry surf.

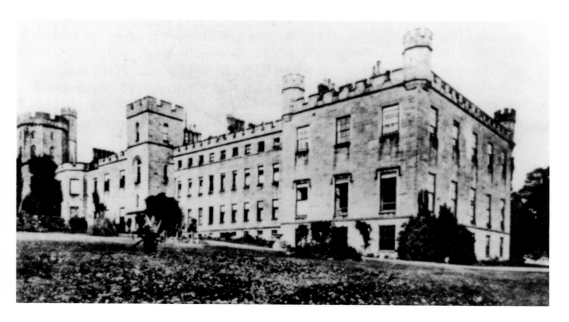

Mulgrave Castle and Lodge House

The present Mulgrave Castle dates to around 1735 when John Schofield was created Duke of Buckingham (1703). Mulgrave Castle was erected as a fitting country mansion for the Duke's wife. The original castle remains are in the grounds of Mulgrave Wood, but rather than rebuild this he chose a new and more aesthetic site on rising ground. When the fourth earl died, all the titles became extinct and the estates went to the Crown who leased them to Constantine Phipps, a grandson of the Duchess of Buckingham, and have remained in that family since.

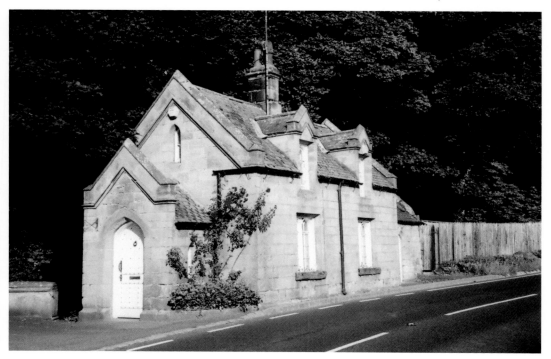

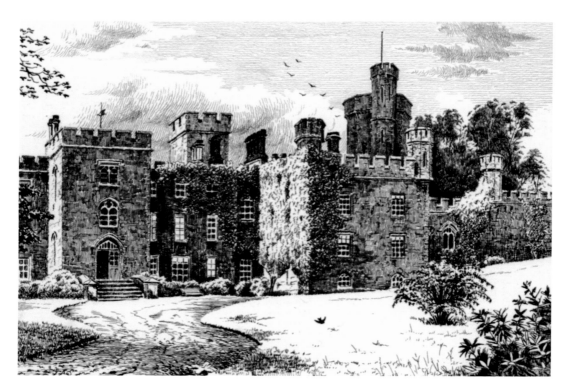

Mulgrave Castle

The estate of Mulgrave boasted a deer park and a staff of hundreds, especially when the third Marquis of Normanby acceded to the title in 1890. It continued to be the main source of both regular and seasonal employment for those of Lythe and district. The estate activities were extended to bring in grouse shooting on the moors and Ugthorpe Lodge was erected as a shooting lodge for weekend parties. The shooting interest also had a huge impact in changing the landscape as roads were cut through and fences taken down.

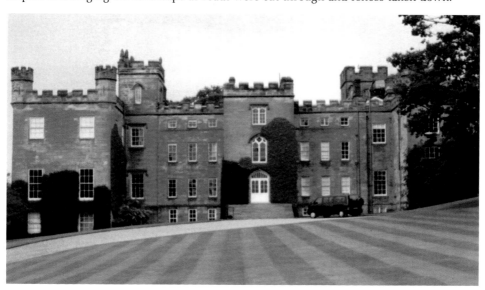

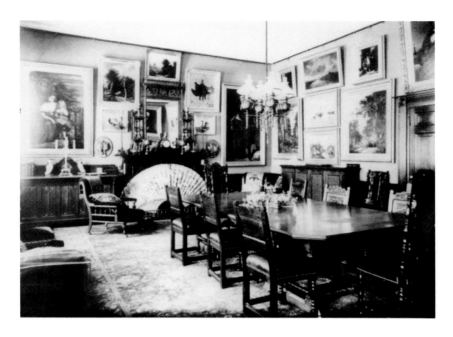

Dining Room & Library, Mulgrave Castle

As can be seen from these photographs by Tom Watson, the interior rooms of Mulgrave Castle were sumptuous as befits a person of such social status and rank as the Duke of Buckingham and his family – although to modern eyes the dining room possibly feels over-dressed. The library (below) is everything a gentleman's office should be with a central desk on which important letters of state were possibly written. The library was a male-dominated area and the lady of the house would rarely visit this preserve.

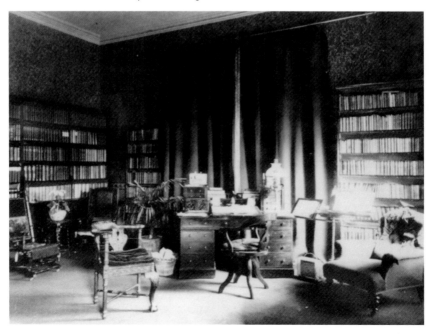

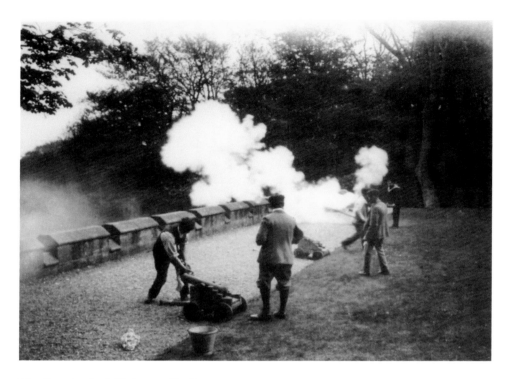

The Quarterdeck Mulgrave Castle

An unusual photograph by Tom Watson showing miniature canons being fired on the 'quarter-deck' at Mulgrave Castle to celebrate the relief of Mafeking during the Boer War. The man with his back to the camera is possibly the third Marquis of Normanby, who is commemorated in Lythe Church with a handsome modern panel. He died in 1932 and his wife outlived him until 1948. She was the daughter of Johnston Foster who originated from the West Riding and made his money in textiles.

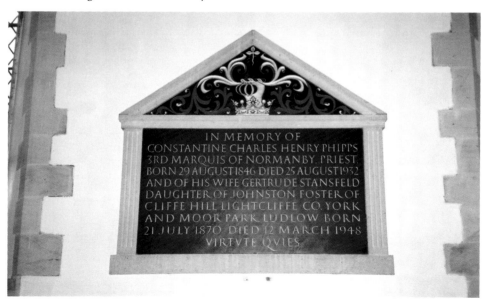

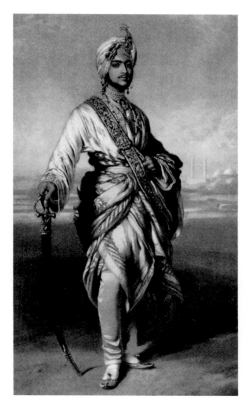

Prince Duleep Singh & Bride

Possibly one of the most interesting periods
in the history of Mulgrave Castle was the time
when Prince Duleep Singh (1838–93) leased it
off Lord Normanby. The prince – the 'beautiful
and charming boy' as Queen Victoria called him
– was the son of Maharajah Ranjit Singh (*d.* 1839)
who inherited the largest state in India, Bengal.
He was brought to this country by the British
government in exchange for giving up his rights
in India. He was educated at the expense of the
state, leaving Oxford University with a First and
was provided with a generous pension for life.
In 1864 the Prince married a German girl, Bamba
Müller (1848–87) in Egypt, who came to England
speaking only Arabic, but was warmly accepted
by Queen Victoria. Indeed, she was godmother
to seven of their ten children. Before settling at
Elveden Hall, Norfolk, he came to Whitby and
was well known around the district where he was
known as the 'Black Prince'. His mother paid him
a visit at Mulgrave in 1863. The portrait of him
(above) was painted by Franz Xavier Winterhalter
at Buckingham Palace in 1845 at Queen Victoria's
instigation. In later life he regretted his decision
to give India to England and turned against his
adopted country. After death he was revered by
the Sikh community and a statue at Thetford was
unveiled in 1969 by HRH the Prince of Wales.

The Seamen's Hospital, Church Street

The Seamen's Hospital was founded in 1675 to assist distressed seamen and to provide relief for their widows and children. It was first sited near the bottom of Boulby Bank; the present building was established on its site in the eighteenth century, but the façade dates only from 1842 and was designed by Sir George Gilbert Scott with a symmetrical Jacobean-style front elevation of two storeys with a touch of baroque. There was extensive exterior restoration in 1995 and the original wood figurehead from the Black Prince above the central arch was replaced with a fibre-glass reproduction.

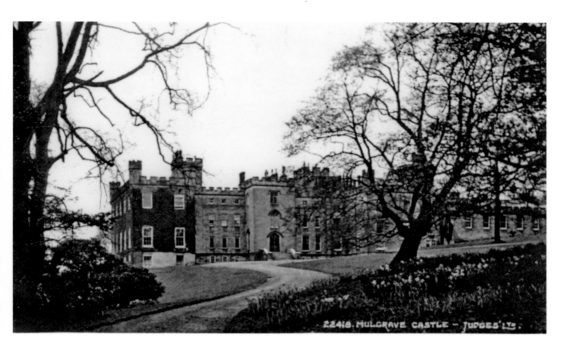

Mulgrave Estate Entrance, Sandsend

At the end of the present car park off East Row Bridge is a public entrance to Mulgrave Woods. At one time the woods were only open to ticket-holders on Monday, Wednesday, and Saturday, when tickets had to be obtained from Messrs Buchannan & Sons, solicitors, in Baxtergate, Whitby, or from the stationmaster at Sandsend. While the opening times are still the same today, a ticket is no longer required. Along the Beck can be found 'The Footman's Leap' which idle gossip says got its name from a footman of Mulgrave Castle jumping to his death from here.

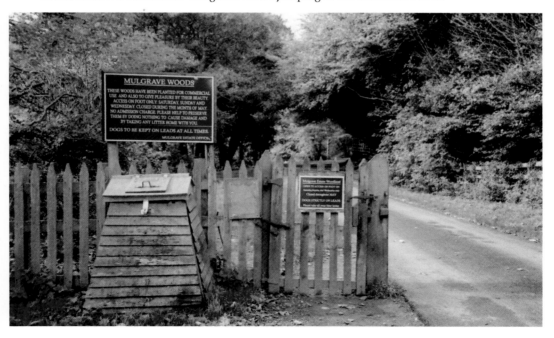

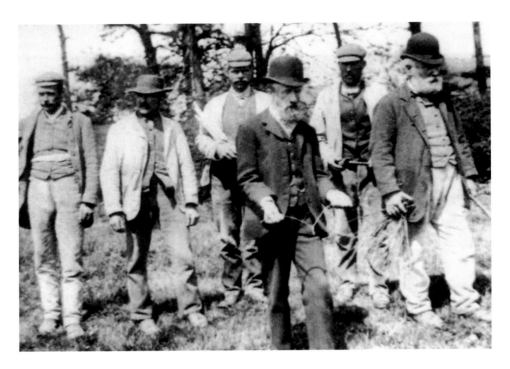

Water Divining, Mulgrave Estate

Another event, a group follow a water diviner at work on the Mulgrave Estate in the 1890s. The men following carry various implements, and the second bearded man, perhaps the diviner's apprentice, carries a handful of spare hazel twigs. It is not known why they are searching for water and it is thought that the object of the exercise was to locate a lost water pipe. Below, just some of the huge retinue of staff required to keep a house like Mulgrave running smoothly, in this instance they are laundry workers *c.* 1880.

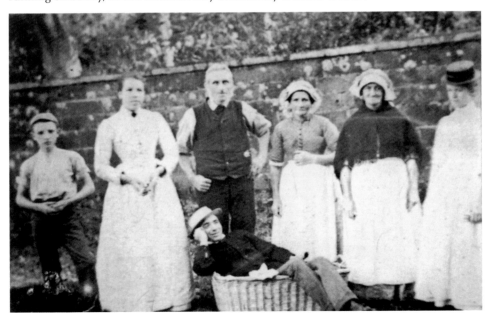

The Photographic Studio of Tom Watson

Although small, Lythe has some interesting connections. The great-grandfather of Rudyard Kipling lived here. Mulgrave Castle, the seat of the Marquis of Normanby, is here and many residents are still employed by the estate. The art of photography figures prominently and Tom Watson (1863–1957), the son of a Mulgrave Estate carpenter, established his studio in Lythe in 1892 seen above. He was a contemporary of F. M. Sutcliffe, the Whitby photographer. Derelict for years, the day I decided to visit to photograph it, it was gone, demolished only two days before.

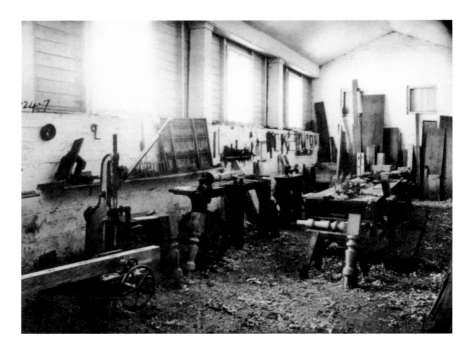

Commerce, Mulgrave Estate

Above, the joinery shop at Mulgrave where Tom Watson and his father, William, worked. In 1863 his father took the position of Head Joiner at Mulgrave, and he and his wife Mary moved into the Lodge where Tom was to be an infant, scholar, apprentice and joiner for thirty years. During the 1880s Tom was laid off, so he began to extend his photographic hobby into a business. His studio, below, was provided by Lord Normanby who gave him a darkroom and commissioned him to take family photographs and events and scenes of the Mulgrave Estate.

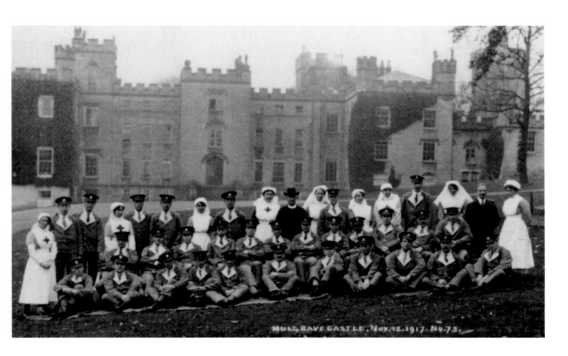

Mulgrave Castle in the War

Like many other stately homes and village halls, Mulgrave Castle served as a hospital and convalescent home for soldiers during the 1914–18 war. Many of the nurses were volunteers. The photograph above was taken in November 1917 and the group includes the Marchioness of Normanby in Red Cross uniform, centre, standing next to her husband, the ordained minister Constantine Phipps. Below, this photograph shows the ward decorated for Christmas on 30 December 1916. On the wall hangs a plaque which reads 'Long Live Lord and Lady Normanby'.

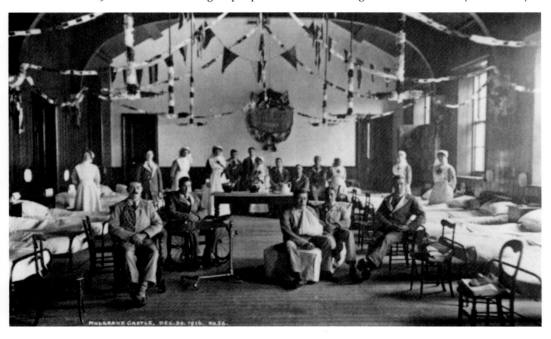

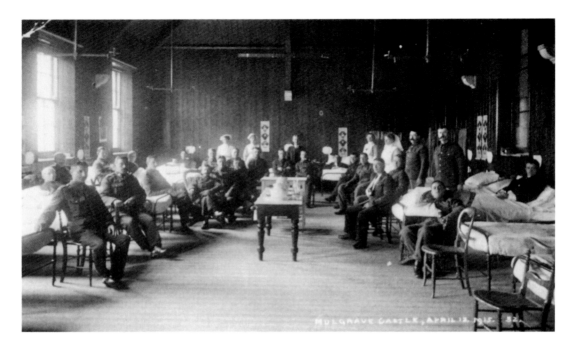

Mulgrave Castle Hospital

Another interior view of the hospital established at Mulgrave Castle taken about 1915. The contrast between the peace and tranquillity and the beautiful estate grounds with the battlefields of Europe must have been quite a considerable culture shock to the injured troops sent to such places across the country. Further, the lives of the local residents seen below, for instance carrying kindle and firewood foraged in the Mulgrave Woods, would also be a sharp contrast, not only in its normality, but in the division between master and servant.

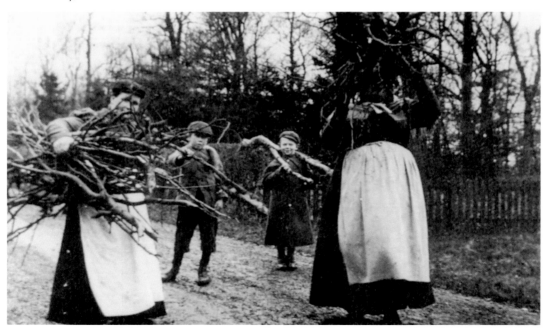

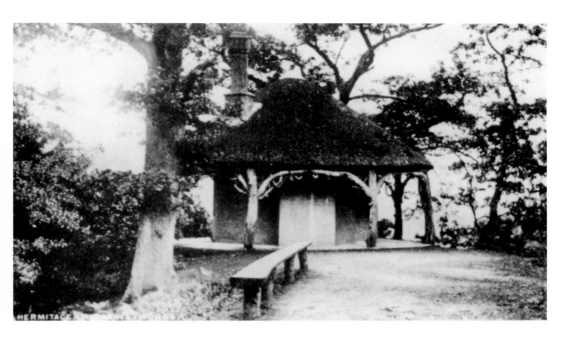

Mulgrave Hermitage & Mulgrave Woods in Spring

'A pretty tasteful structure, the overhanging roof thatched with ling to protect it from the rain, and raised on substantial pillars of oak to harmonise the situation "hard by a forest side". Not far off "a crystal stream did gently play"; and the deep foliage of autumnal woods, amidst which gleamed the proud battlements of Mulgrave Castle, with a rich, fine glimpse in the distance of the "ocean's blue water's," formed a prospect beautiful and unique.' Although private, it is possible to walk through the woods on Wednesdays, Saturdays and Sundays.

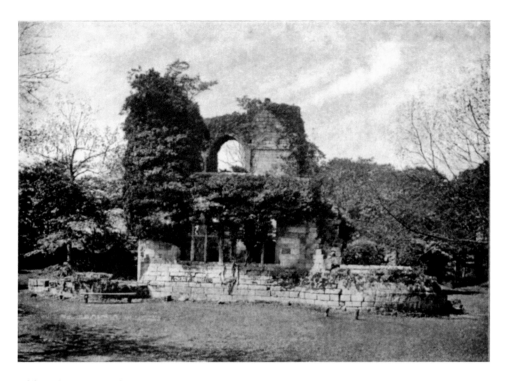

Old Mulgrave Castle

The first castle at Mulgrave was built by Nigel Fossard some time before 1220. He chose a site at a strategic point now known as Foss. This castle, of which the motte still survives near the former site of Foss watermill, was a simple wooden fortification on an artificial mound surrounded at its base by a stockade and an outer ditch. However, Fossard, when laying out Foss Castle, took advantage on one side of a precipitous little gorge through which runs Sandsend Beck, thereby obtaining a natural defence at that point.

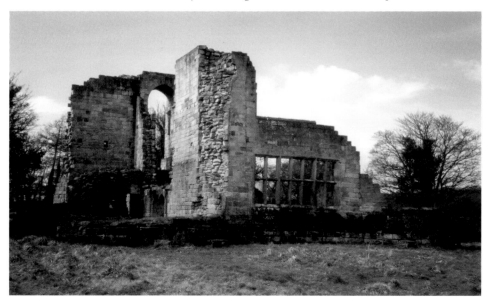

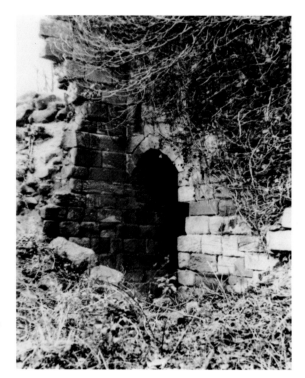

The Ruins of Mulgrave Castle

In 1545 John Leland, the King's antiquarian, wrote that 'Mougreve Castelle standith apon a Craggy Hille; and on each side of it is an Hille far higher than that whereon the Castelle standith. The North Hille on the Topp of it hath certen stones commonly caullid Waddes Grave, whom the People there say to have bene a Giant and owner of Mougreve. There is by these Stones a beck yn out of the Mores by Mougreve cum doun by many Springes. Two bekkes one ech side of the Castelle, and yn the Valeys of the two great Hilles. The one is caullid Sandebek, the other Estbek, and shortely after goith to the Se[a] that is not far off.' From the Fossard family the castle came into the possession of Robert de Turnham through marriage and then again, because there were no male heirs, through marriage it came into the Mauley family in whose hands it stayed for 200 years.

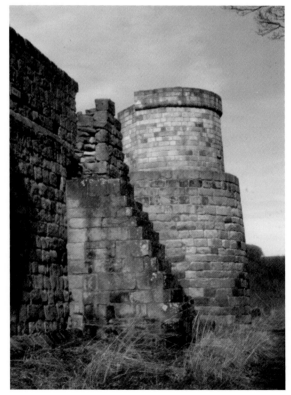

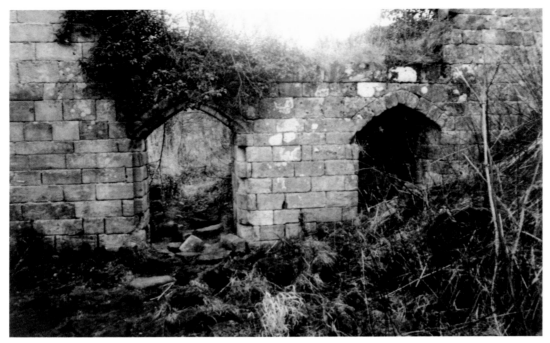

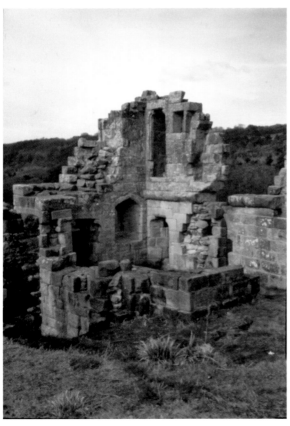

Mulgrave Castle During the Civil War

In 1634 Mulgrave Castle was surrendered to King Charles I, but at the start of the Civil War it was garrisoned by Cromwell's men. However, in 1643 a Royalist force took it back and held it for the Crown. Shortly after, Colonel Boynton, fighting on the side of Oliver Cromwell, retook it in June 1644, allowing the Royalist force to leave with drums beating and colours flying. In 1646 it was ordered that Mulgrave Castle be made untenable, but it was not until 1647 that it was actually partially taken down.

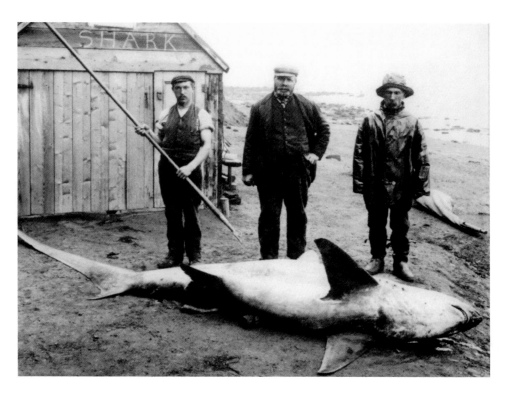

Shark Fishing, Kettleness

One of the headlands of Runswick Bay is known as Kettleness (below) which has a distinct profile gained from the days when it was mined for alum. Indeed, it was so undermined that eventually, in the late nineteenth century, the village of Kettleness quietly slid into the North Sea. The waters of this part of the North East Coast are particularly turbulent and attract many unusual species of aquatic life, like the giant shark caught on 27 August 1898, and photographed by Tom Watson. Whales are also known to have beached themselves on the shore.

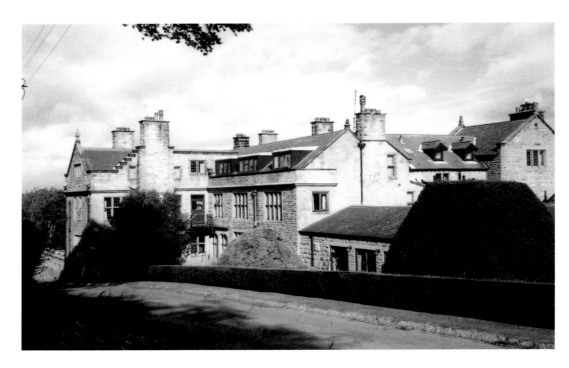

Dunsley Hall

The name Dunsley is derived from the Celtic word *Dun*, a fortified hill, and *ley*, meaning land reclaimed from the forest or marsh; and there is every evidence that the hill on which the school is built was once surrounded by water on three sides. In order to demonstrate the antiquity of other place names around here it is only necessary to mention the word 'Raithwaite', a Celtic word meaning 'a hill in water'; 'Newholm' the Saxon word for 'new dwelling'. Dunsley Hall was built in the nineteenth century for a wealthy ship owner.

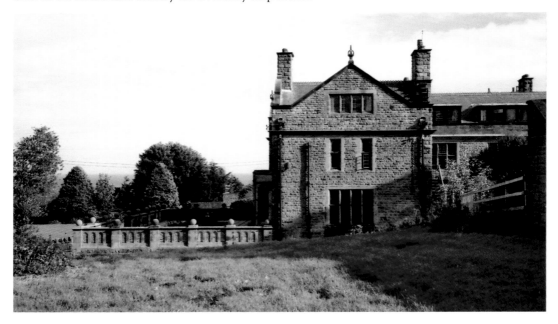

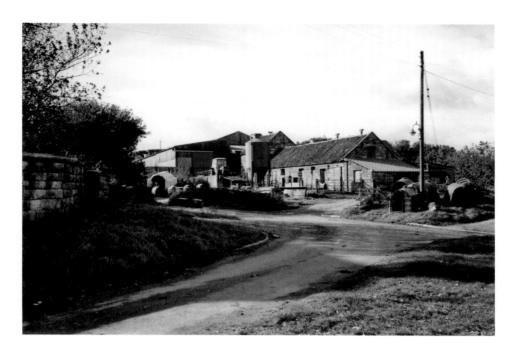

Dunsley Village

Dunsley stands on elevated land about a mile from the coast and is reached by a narrow road leading off from the main coastal highway between Whitby and Sandsend. From Dunsley a Roman road extended over the moors to York, and parts of this ancient road are yet visible. It is believed a Roman fort once stood on the mound in the centre of the village and on which the present nineteenth chapel is erected. The mound certainly has every appearance of being artificial, which strengthens this belief. Today, Dunsley is a sleepy backwater.

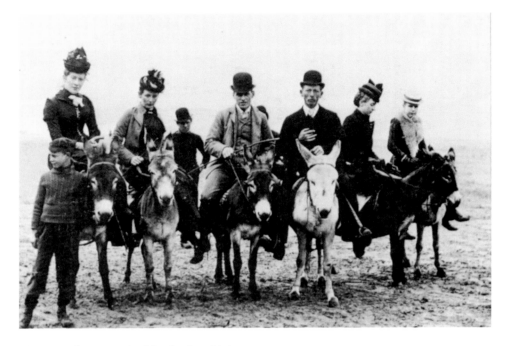

Oh, I Do Like To Be Beside the Seaside!

A century apart, but the delight and joy are timeless; people relish being beside the sea. Sandsend, as the name suggests, is where the beach runs out to the north of Whitby. A seaside paradise with soft sand for building sandcastles, rock pools for the inquisitive to explore, wide open country for the energetic rambler and a gently sloping beach to the North Sea for a refreshing dip or a quick ride on the donkeys and then a deckchair to relax and soak up the sun. Who needs sunny Spain, eh?

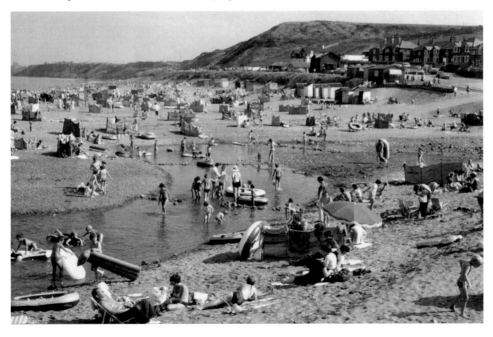

A Village of Two Halves

At the outset we mentioned that really Sandsend is two separate hamlets with almost two separate identities, but they are both villages of contrast; on the one side we have sea, sand and shore, and on the other, fertile and lush wood valleys. Both facets have helped to shape the characters of the people and to provide constant employment from fishing to farming, brutal industry to 'genteel' service to the lord of the manor at the 'big house' – and it still could almost be said of today's residents.

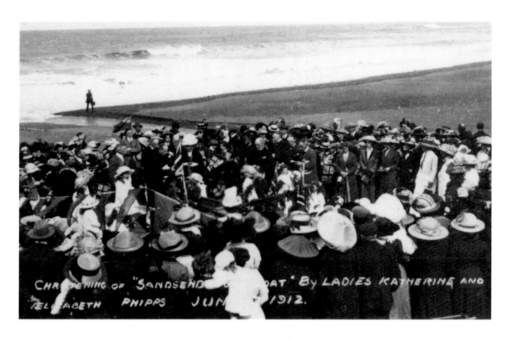

CHRISTENING OF "SANDSEND ... OAT" BY LADIES KATHERINE AND ELIZABETH PHIPPS JUN ... 1912.

North Yorkshire & Cleveland Heritage Coast & Lifeboat

Sandsend forms part of the North Yorkshire & Cleveland Heritage Coast walk, a long-distance footpath that winds its way along the dramatic and sometimes treacherous coastline. The RNLI lifeboats at Whitby and Runswick Bay are often called out to perform rescues of those who do not heed the warning signs about dangerous cliffs or are cavalier about the tidal warnings and continue unaware of the dangers that they are walking into. At one time Sandsend had its own lifeboat, and the postcard above shows a new lifeboat being christened in June 1912.

The Royal National Lifeboat Institution
The concept of shore-based lifeboats
began when the first of these was
launched at South Shields in 1789. From
that period, a number of private lifeboats
existed to serve various ports and fishing
towns to protect 'home' fleets and
visitant craft in local coastal waters. The
idea of lifeboats was so well founded
that, by the year 1802, Lloyds of London
announced that they would make
available £2,000 toward the building
of lifeboat stations around England. By
September of that year, with a small
donation from Lloyds, the first lifeboat
and lifeboat station was established here.

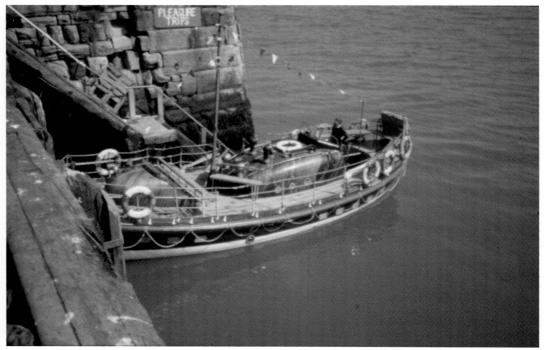

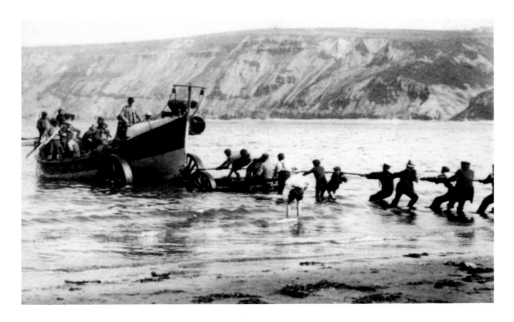

The Lifeboat Crew

The lifeboat being towed ashore onto its carriage, possibly after an inspection judging by the bowler-hatted gentleman standing near the bows. From the variety of clothes of those pulling, it seems everyone was eager to assist in this task – seamen's jerseys to formal suits and straw boaters. Below, Coxswain John Freeman and his gallant crew. John Freeman was one of the most decorated lifeboatmen of the Victorian era and twice received the highest honour for bravery, and the deeds of his crew in the lifeboat *Robert Whitworth* were legendary in the annals of the RNLI.

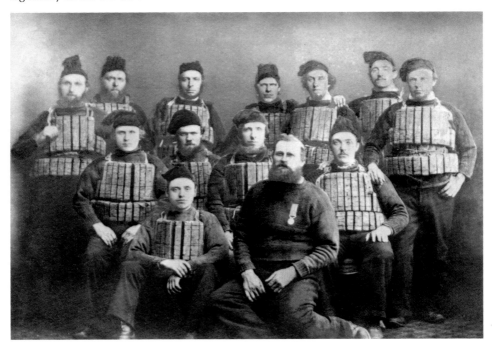